Basic
Watercolor
TECHNIQUES

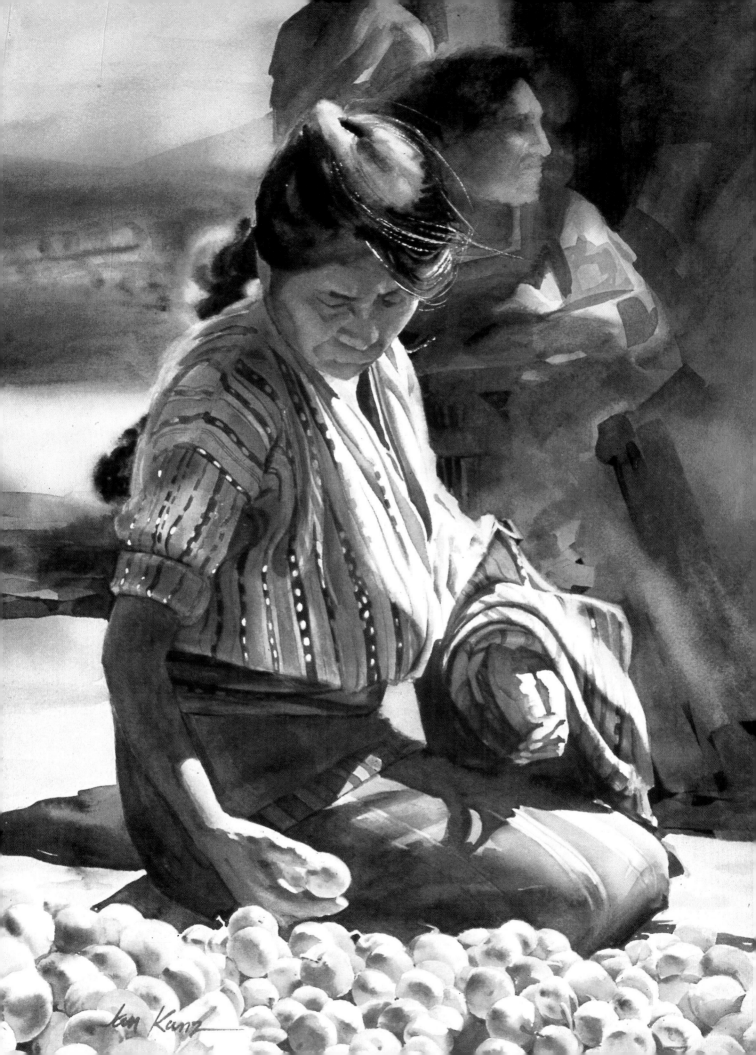

Basic Watercolor
TECHNIQUES

edited by

GREG ALBERT
and
RACHEL WOLF

NORTH LIGHT BOOKS

Cincinnati, Ohio

02 01 00 99 12 11 10 9

Library of Congress Cataloging-in-Publication Data

Basic watercolor techniques / edited by Greg Albert and Rachel Wolf.— 1st ed.
 p. cm.
 Includes index.
 ISBN 0-89134-387-3
 1. Watercolor painting—Technique. I. Albert, Greg. II. Wolf, Rachel.
 ND2420.B37 1991 91-8845
 751.42'2—dc20 CIP

The following artwork originally appeared in previously published North Light Books. (The initial page numbers given refer to pages in the original work; page numbers in parentheses refer to pages in this book.)

Austin, Phil. *Capturing Mood in Watercolor*, pages 46-47, 62-70, 87-93, 99; (acknowledgments page, pages 46-47, 56-72, 64-73).

Couch, Tony. *Watercolor: You Can Do It!*, pages 13, 15-19; (pages 2-7).

Draper, J. Everett. *People Painting Scrapbook*, pages 11, 33-39; (pages 108-115).

Hutchings, LaVere. *Make Your Watercolors Sing*, pages 10-11, 15-19; (pages 49-55).

Johnson, Cathy. *Painting Nature's Details in Watercolor*, pages 36-37, 42-43, 57-67, 79-97, 123; (opposite introduction, pages 62-63, 74-75, 77-95, 97-107). *Watercolor Tricks & Techniques*, pages 12-15, 18-19, 50-51, 88-95; (pages 8-17, 38-41, 44-45).

Kunz, Jan. *Painting Watercolor Portraits that Glow*, pages x (opposite introduction), 50-53, 55, 112-115; (opposite title page, pages 34-35, 37, 42-43, 116-119).

Stine, Al. *Watercolor: Painting Smart*, pages 26-27, 30-31, 34-45; (pages 18-33).

Interior designed by Sandy Conopeotis

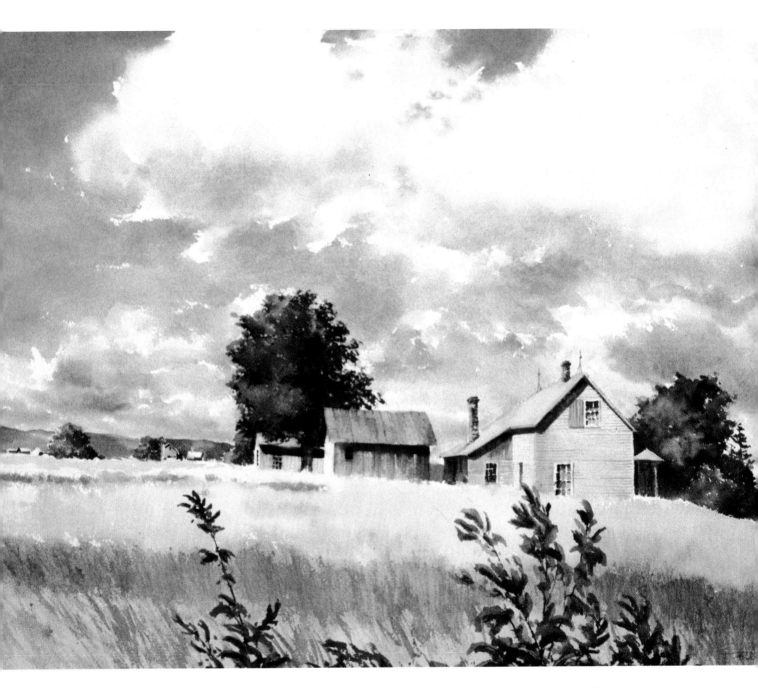

ACKNOWLEDGMENTS

The people who deserve special thanks, and without whom this book would not have been possible, are the artists whose work appears in this book. They are:
Phil Austin
Tony Couch
J. Everett Draper
LaVere Hutchings
Cathy Johnson
Jan Kunz
Al Stine

TABLE
of
CONTENTS

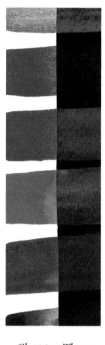

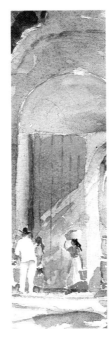
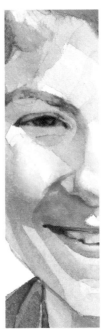
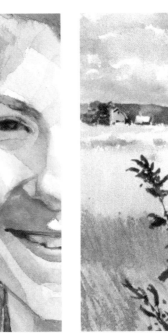
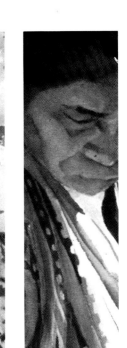

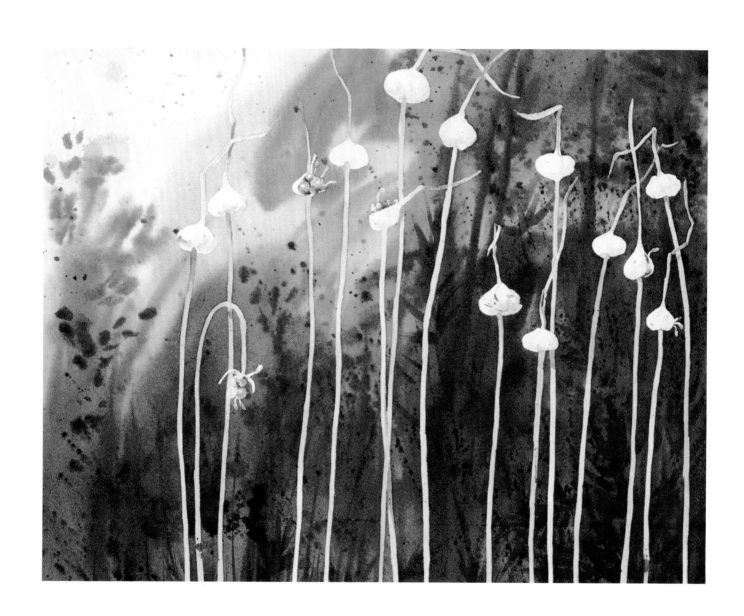

INTRODUCTION

Watercolor is the most exciting way to paint. That may seem a bold statement, but we believe it is true. No other painting medium comes close to the purity of color and radiance of transparent watercolor. And watercolor is no more difficult to learn than painting with oils or acrylics. Of course, to be a competent painter you will have to work at it, but we believe you can begin to see satisfying results from the start.

Watercolor may have a reputation for being a difficult medium, but it is not deserved. Perhaps it is easier to make a bad watercolor than to make a bad oil painting, but it is no harder to make a good watercolor than a good oil or acrylic painting.

The key to success with watercolor is developing an understanding of the medium's unique character. This book will show you how watercolors work, and how to take advantage of all their special properties.

We have assembled this book from some of the best teaching on watercolor that's available—everything the beginner needs to get off to a smooth start. In the first chapters you will find useful information about materials and techniques, and some invaluable information about color. The latter part of the book teaches some basic principles that will help you paint some of the most popular watercolor subjects such as landscapes, flowers, water, and snow. The only additional ingredients you will need are practice, and the knowledge that interest and effort overcome any lack of that elusive quality we call "talent."

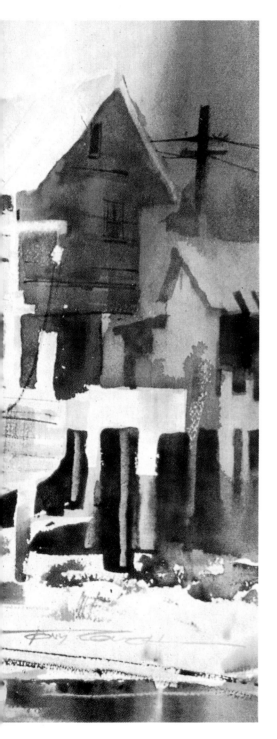

BASIC MATERIALS
Everything You'll Need to Get Started

In general, all watercolor artists use the same equipment and supplies, with differences dictated by personal taste. While good equipment is a help, there is no magic in tools; award-winning paintings have been painted with the simplest of them.

Essential Tools

In the next few pages, you will find an overview of artists' tools, with some tips on how to choose and use them. Then, armed with that basic knowledge, you'll explore some techniques that will help you approach your watercolors with new understanding—and new ideas.

Choosing a Palette

You could paint using only a plain white plate or a butcher tray for a palette—by putting a puddle of each color near the edges and using the middle for mixing. But there's an economic advantage to using a palette with a cover: it will keep the pigment moist and soft, so you won't waste time or money scraping off old paint and throwing it away. Dried, hard pigment will never give you the dark, rich values and bright chroma you need.

Paint in a closed palette will normally stay moist for four days or so. Keeping a damp sponge in your palette will keep the paint moist a little longer, but mold may form on the paint.

The best solution for the problem of dried paint is simply to paint every day. Unfortunately, few of us can, so the next best course is to keep a spray bottle (filled with water) near your palette. Open the palette every fourth

day or so if you haven't been painting and spray the paint. It only takes seconds, and your paint will remain soft indefinitely; you'll never again have to waste it.

Keep the spray bottle with you when you paint. Pigment has a way of drying as you paint—particularly outdoors.

When choosing a palette, look for one with deep wells, each about one inch square or larger. To paint broadly and boldly you'll need to use a large brush, and a large brush is useless without a large well of paint! Keep the well at least half full.

Basic Brushes

In general, paint with as large a brush as possible to force yourself to paint broadly and boldly. But smaller shapes do require smaller brushes. Buying a brush size to fit the size and shape of every subject you choose to paint may delight the brush manufacturers, but it's not practical or necessary. The brushes mentioned below should be adequate for your painting needs. You may want to experiment with other brushes, though, as your budget and your imagination allow.

There are two principal shapes: flats (which have square chisel-point ends) and rounds (which are round and end in a point). They come in all sizes, but to start try a two-inch, a one-inch, and a one-quarter-inch in the flats, a no. 8 round, and a *rigger*. The rigger is a small, round brush with longer hair. (Since many art store clerks don't know the term "rigger," you may have to be more specific. Grumbacher makes one called "series 4702." A no. 3 or no. 4 is good.)

The flats are used for angular

shapes, and particularly for sharp, crisp corners. The rounds make curved shapes easier to paint. The smaller shapes and details are painted last with the smaller brushes. Use a rigger for the thin lines (calligraphy).

Brushes are made of various types of hair, the best being red sable, which is expensive. White nylon brushes are also available and work nearly as well, at a lower price.

The store clerk may not know these brushes as "nylon," but rather by the trade names, such as Erminette, White Sable, etc. You'll recognize their snow-white appearance.

Paint—The Essential Tool

Tube paint is the best; its toothpaste consistency allows varying amounts of paint to be scooped onto the brush. There are several brands on the market: Winsor & Newton, Grumbacher, and Liquitex are popular. The brand isn't important as long as the paint is permanent—it shouldn't fade on the painting in a few years.

The following colors constitute a good basic palette, but as you will see in later exercises and examples, they can be supplemented with additional colors.
- lemon yellow or Hansa yellow
- new gamboge or cadmium yellow
- raw sienna or yellow ochre
- burnt sienna

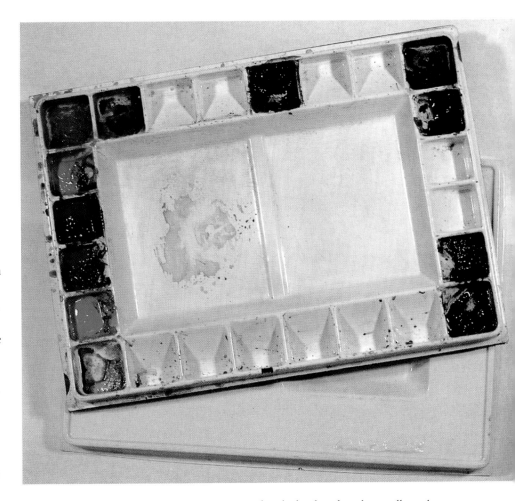

- cadmium orange
- cadmium red
- alizarin crimson
- viridian or thalo or Prussian green
- Winsor or thalo or Prussian blue
- ultramarine blue

Since you'll be thinking cool or warm and light or dark as you paint, it makes sense to arrange the palette that way. Put cool colors on one end and warm colors on the other, and within these groups, arrange colors from light to dark. Most importantly, place each color so you can locate it readily as you paint.

The ideal palette has deep wells and a cover to keep the paint moist. How the pigments are arranged is unimportant, as long as each can be located readily while you are painting.

Pointers on Paper

Watercolor paper is available in four weights (thicknesses) and three textures. The weights are 400, 300, 140, and 75 pound, but the exact weight may vary slightly. The thickness of the paper increases with the weight. The textures are hot-press (smooth), cold-press (medium/rough), and rough. Texture does not influence the price, but weight does; the higher the weight, the higher the price. Watercolor paper comes in 22x30-inch sheets, loose, or in a quire of 25 sheets. It is also available in a larger 25x40-inch "elephant" sheet, and a roll 43 inches wide by 10 yards long.

You will also find paper in pads or "blocks" in sizes smaller than 22x30 inches. These pads are usually 140-pound sheets, glued at the edges on all four sides. The sheets can be separated with a knife.

There are several brands of paper on the market, and each produces slightly different painting results. If you paint very long, you'll learn to use the best you can buy—the results are better and the difference in price not great.

Since any particular texture will be the same in all weights, there is little advantage in using one weight over another, except for price. Some painters, however, prefer thick 300- and 400-pound paper because it won't wrinkle as they paint. But this minor handicap is easily overcome by *stretching* the paper, described below. Other artists simply ignore the slight wrinkling. Wrinkling *is* a problem with 75-pound paper, and although it can sometimes be stretched successfully, it may tear away from the tape, staples, clamps, or whatever is used to fix the

The simplest way to paint without an easel is to lay your board on the ground with a small rock under the far end to tilt it toward you. Then sit on the ground and spread your gear around you.

paper to the board.

To stretch a new sheet of paper, first soak it in water, then fix it on all sides to a board. The board can be made of anything, the "fixing" medium can be tape, staples, clamps, or tacks. If you use tape, it should be brown paper tape, such as a butcher might use, and not masking or freezer tape. The glue on the masking tape is too weak, and the paper will pull away from it as it dries.

How does stretching your paper work to prevent wrinkles? When paper is soaked, it expands. After allowing about five minutes for expansion, the paper is fixed to a surface. The paper will try to contract to its original size as it dries, but, being fixed, it cannot and will instead dry stretched to the expanded size. Since the paper cannot expand when wet again (as when painting on it) it avoids wrinkling.

As an alternative to stretching, some watercolorists either clamp the paper as they paint, or ignore the wrinkling altogether. If you can ignore the slight wrinkling that may occur as you paint, you'll find it makes no difference, and

the sheet will revert to a perfectly flat condition as it dries.

In any case, a completed painting can be placed in your framer's dry mount iron (don't let him dry mount it!) for two minutes, and it'll be as flat as it was when it came out of the quire.

What About an Easel?

You don't have to have an easel; it is expensive, but it is practical for use outdoors. You'll find easels in art supply stores and advertised in art magazines.

There are ways of working without an easel. If your budget is tight, experiment with these methods rather than investing in an easel right away. The simplest way to paint outdoors without an easel is to lay your board on the ground, with a small rock under the far end to tilt it toward you. Then sit on the ground and spread your gear around you. Better yet, take a folding card table with you and paint standing up. You probably wouldn't want to use an easel indoors; it's more convenient to paint standing at a table.

A Watercolor Board

You'll need a board to support your paper while painting. Any size board will do if you tape, pin, or staple the paper to it. If you use clamps, the board must be only slightly larger than the paper you use. This is so the clamp, which fits over the edge of the board, can reach the paper. Try a 16x23-inch board for the half-sheets and a 23x31-inch for the full sheets. Of course, if you're painting on a block, no support is necessary.

It's best if your board is waterproof so it doesn't suck the water out of your wet paper from behind, causing the paper to dry too soon. The water-colorist's eternal problem is keeping the paper wet enough, long enough.

Plexiglas, Lucite, Formica, or any smooth plastic surface works well. One-quarter-inch plywood, sealed

with waterproof spar varnish on both sides, will do. You must coat both sides, or the board will dry warped. A fair substitute is Masonite, which is slightly porous. This surface can also be improved by sealing both sides with spar varnish.

Miscellaneous Materials

Everyday Tools. You'll find a variety of everyday things that can contribute to your paintings. An old towel or rag will be useful for spills. You'll need a sponge and facial tissue to dry brushes and blot areas of your paintings. Artificial sponges are available at hardware stores, but be sure you get one made of *cellulose*. Any other artificial sponge is not absorbent enough. A small, elephant-ear-shaped natural sponge is useful for lifting out light areas in a wet painting.

Water Containers. Two tin cans, such as coffee cans, are good for holding water. Use one for clean water and the other to wash brushes between color selections. Plastic containers like those used for refrigerating food are also good.

Metal Clamps. Metal clamps from an office supply store are ideal for clamping the paper to the board—you'll need at least four. If you tape the paper, use brown gummed paper tape (butcher tape).

Texture Tools. Tools for scraping or making other marks on wet pigment on paper are part of every watercolorist's gear. All painters have their favorites: a pocket knife, the end of the brush handle, a razor blade. You'll find others as you experiment.

Pencils. An ordinary no. 2 pencil is fine for sketching in your sketchbook and on the paper. Don't use no. 3 or "H" series art pencils; they are too hard and can damage watercolor paper. A wide carpenter's pencil makes it faster and easier to fill in large, dark areas in your sketchbook studies.

Erasers. The best eraser is a soft one, like the new plastic eraser or the old art gum. The plastic erasers leave less debris.

Sketchbook. You'll need a sketchbook for recording ideas, notes, and sketches. Mine is an 8 1/2 x11-inch bound book of bond paper.

Don't limit yourself to the tools and materials we've covered here, and don't load yourself down with unnecessary items. The unfailing mark of fledgling painters is a preoccupation with equipment; they buy too many brushes, too many hues of paint, and so on. I suspect they secretly hope good paintings are merely a matter of proper (or enough) tools; if this were true, anyone with an art supply catalog and a steamer trunk would be hanging paintings in the Louvre.

Beautiful work is the result of what you do with your tools. And that requires *your* heart, *your* mind, *your* determination, and *your* time—none of which is available in anyone's art supply catalog. This equipment resides within you right now, and with time and practice will make *any* brush produce beautiful paintings on *any* paper!

Read on. Let's find out what to do with these "supplies" you've been hiding within yourself all this time.

More About Paper and Brushes

Paper

Watercolor paper is alive; it's beautiful and varied and, sometimes, as unpredictable as the medium itself. While you're developing your skill, you may want to concentrate on one type of paper. Later, you will want to try many different papers until you find one that suits most of your needs. Consider all the possibilities: rough, cold-press, or hot-press; handmade or made by a mold; French, Italian, English, or American; 100 percent rag, mulberry, or rice paper, or even fiberglass (yes, Strathmore's Aquarius).

You may like the 300-pound or heavier papers, if you work very wet. For most applications, 140-pound paper works well; if you plan on stretching your paper before working, try 75-pound paper, but take care not to tear it.

Fabriano 140-pound cold-press is generally a good paper for most things. But consider a good hot-press paper or board for special effects, and Crescent's cold-press watercolor board for projects that may get rough handling.

Take a look at our samples, but don't stop there. This is one area that needs hands-on experience.

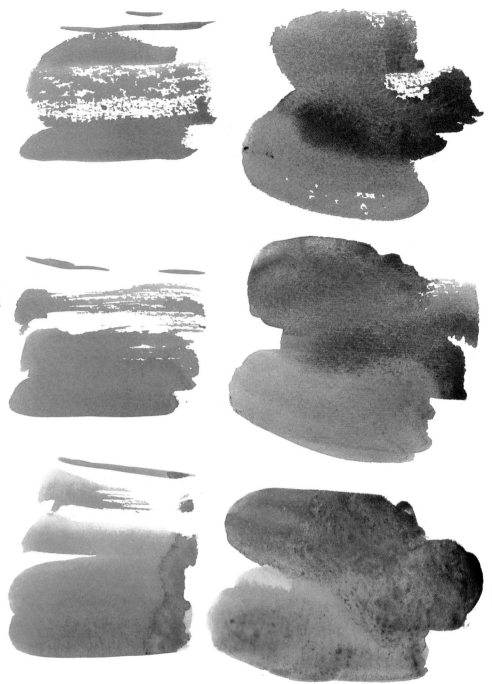

Our samples show the differences in the three basic paper types: rough (top), cold-press (center), and hot-press (bottom). Notice the blue strokes at left; here, one or two straight strokes were made with the body of the brush—one dry-brush stroke, and one with the tip for each kind of paper. You can see how much more open the strokes are on rough paper; the pigment hits the "peaks" of the paper without going down into the "valleys." The strokes also are smoother when wet on the rough paper; wet strokes tend to flatten out on this paper.

In the right-hand column, we've mixed colors on each paper to show you how each takes varying pigments. A smoother blending is possible on rough paper, again because the pigment evens out in all the miniature valleys. Blending is smooth enough on cold-press, but just plain fun on the hot-press. Notice the way the colors kind of pull away from the edge and puddle where they meet.

How you hold your brush affects the way the pigment goes on with each kind of paper. The two samples at left on this page are done on rough paper. Above is the stroke of a flat brush held perpendicular to the paper's surface. Below it is shown what happens when the brush is held flat to the paper, and a rapid stroke is made with the body of the brush rather than the tips of the bristles. The effect is very open and sparkling where the dry-brush stroke was used.

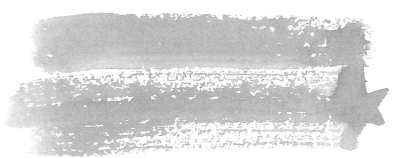

This sample is on cold-press paper. The samples were made first by holding the brush vertically and then almost horizontally (below). *You still get the benefit of a bit of texture in the openness of the strokes, but with a little more control and conscious decision making than is possible with the rough paper.*

On the hot-press paper shown here, the strokes are nearly alike because there are no hills and valleys to affect the openness of the stroke. In order to get a dry-brush effect at all, it was necessary literally to dry the brush on a piece of tissue.

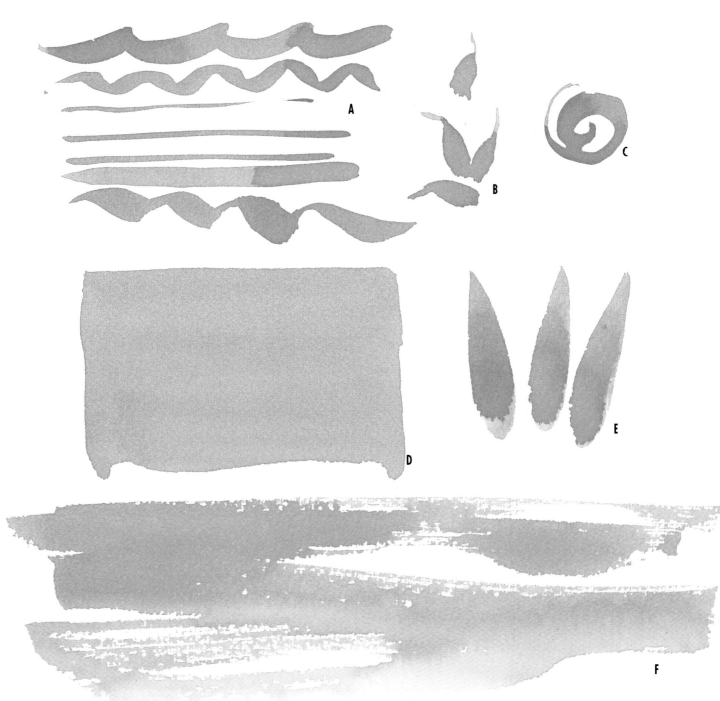

Make a page of brushmarks with your favorite watercolor rounds. These are a few of the things brushes are capable of: **A** is simply a variety of strokes made with the tip of the brush—waves, squiggles, fine lines, bolder ones. **B** shows the great versatility of the round brush—the tips of these leaflike shapes were made by holding the brush lightly and touching just the end of the paper. Then the body of the brush was brought down into full contact. **C** A widening spiral made by gradually increasing the pressure on the brush. **D** A flat wash, easily accomplished with a round brush. **E** Strokes made with the entire body of the brush—it's a no. 12. These are shapes that could be useful in a number of ways—leaves, fish, petals, bird's wings. **F** The round brush's capability for making broken, dry-brush washes is shown. **G** Small dots made with the tip of the brush. **H** An eye painted with the pointed tip. **I** The full brush shape again, this time with the tip dipped into another color. Notice the variety of color and value these strokes have. **J** Broad strokes with a full brush—they could be the beginning of a broad landscape. **K** Small, wavelike repeated strokes. **L** For this effect the brush was loaded, then dried somewhat and the bristles spread, jabbing upward with them. **M** A rough, scumbled stroke with the side of the brush.

Basic Watercolor Techniques

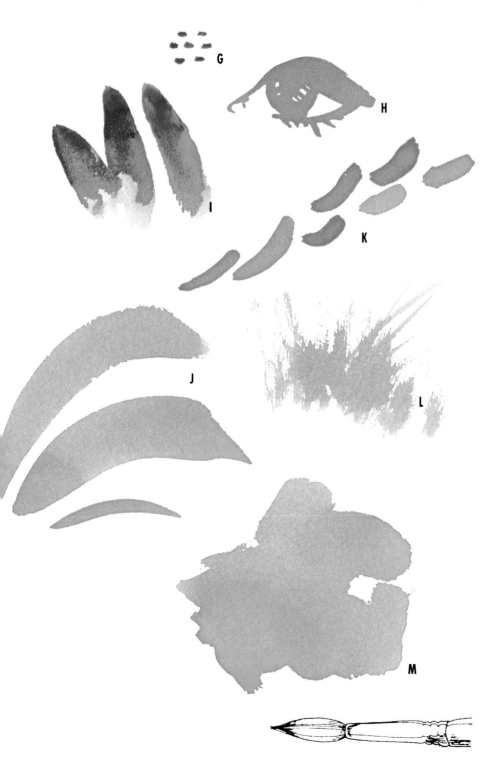

Round Brushes

Brushes are the most versatile and easily available of any tools; learning the best ways to use them will allow you to create very nearly any effect you want.

To get you going, experiment with these basic tools in as many ways as you can think of. Start with the obvious, but then push, pull, dab, or work with your brushes until you are thoroughly familiar with them. With experience you'll know just which brush to choose and what to do with it when you want a particular effect.

Round watercolor brushes come in sizes from 000 to 16 or so. These brushes hold a lot of paint in their deep bodies and should come to a good point when shaken briskly. If your old beloved round has lost its point, don't despair and throw it away; it's still a dandy tool for a lot of rough effects you wouldn't wish on a fine new sable.

And speaking of sable, it's a premier luxury and one you certainly owe yourself; a brand favored by many artists is the Strathmore kolinsky red sable. These brushes are the crème de la crème. Sable isn't a necessity of life; it only seems that way sometimes. And no brush, no matter how magical, will make us better painters—we do that ourselves, even if we have to work with a sharp stick. The white sables, sablends, or ox hair brushes are all fine compromises if you are working on a limited budget. The synthetic fibers generally seem to hold a bit less pigment; you'll have to return to your palette more often.

Flat Brushes

Flats are favorites for everyday painting. Many artists like the slightly puddled washes they can pull with them, and the unexpected effects. They're versatile, too. Don't think because a brush is square on the end that your strokes have to be square, too. Paint with the end of the brush, or the side. Manipulate the body of the brush for varied strokes. Scrub it into your paper. Push up; pull down. Jab and poke your brush at the paper for new effects. (This sounds terribly hard on a good watercolor brush. You'll be happy to find how much less expensive flats are than the round brushes. Even a nice big sable flat is much less expensive than a round of comparable size.)

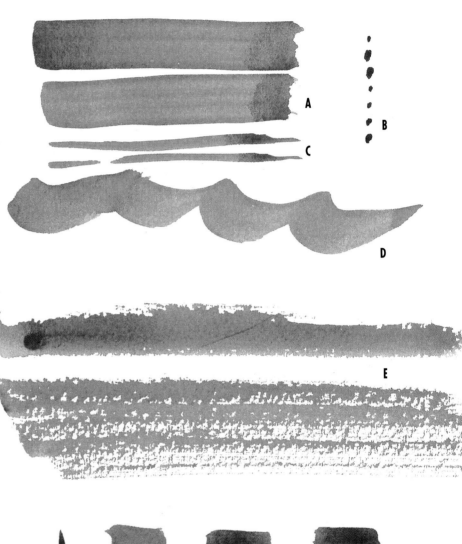

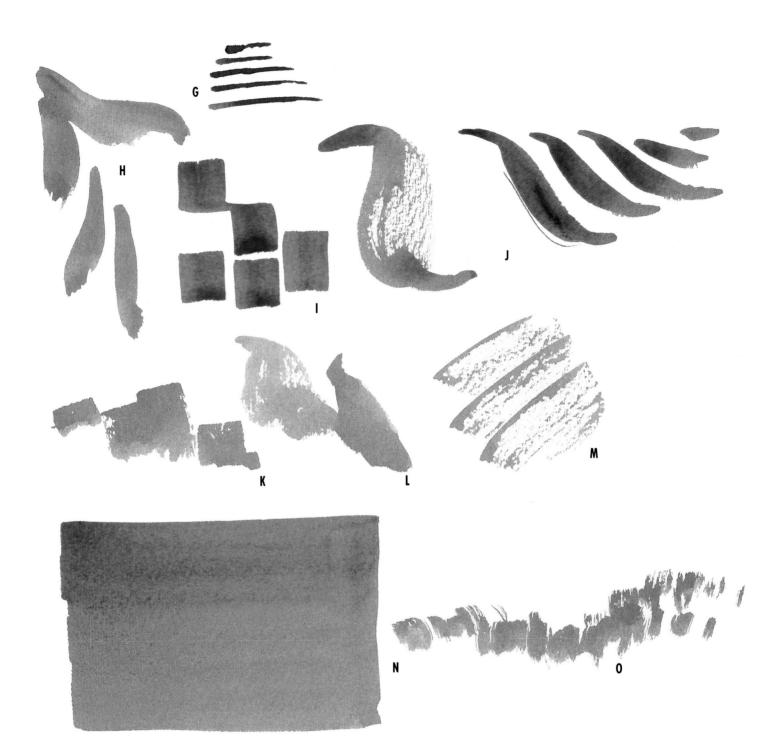

These samples were made using a half-inch flat brush. **A** *Flat strokes made with the ends of the bristles. This could be useful to depict anything from a slanted roof to barn boards to woodgrain.* **B** *A corner of the brush makes tiny dots.* **C** *The brush was stood on end and just the tips of the bristles were wet.* **D** *The tips of the bristles make a wavy line.* **E** *The outside edge or side of the brush will make nice, broken, dry-brush effects.* **F** *A stairstep or checkerboard effect, taking advantage of the shape of the brush itself.* **G** *The ends of the bristles can be used for stamping.* **H** *Try branching out, turning the brush this way and that using the side and tip at once.* **I** *Marks resembling windows made with flat strokes.* **J** *Curves of varying widths.* **K** *Repeated quick strokes.* **L** *Dry-brush squiggles.* **M** *Thoroughly wiped, the side of the brush will make beautiful open marks.* **N** *A flat brush can give just a bit of variation to a flat wash.* **O** *The brush was dried on a tissue and jabbed upward to create short "grass."*

Special Brushes

Don't stop with flats and rounds. Riggers or liner brushes, fan brushes, oval sky wash brushes, mops, bristle brushes, stencil brushes—they're all fair game to get your own brand of special effects.

We all have our special favorites. Don't feel you must spend a fortune on a whole quiver of brushes. Favorites include the Strathmore kolinsky no. 12, a three-quarter-inch flat with aquarelle handles for scraping, a barbered fan brush, an ancient stencil brush for spattering and drought effects, and a couple of riggers. Yes, the no. 12 does cost a king's ransom. Many artists think it's worth it.

Play with your brushes to learn just what each is capable of doing. Even if you're an old hand at watercolor, it never hurts to go through a few exercises just to warm up. There's always the chance you'll discover a bold new stroke you didn't know your old brushes could pull off!

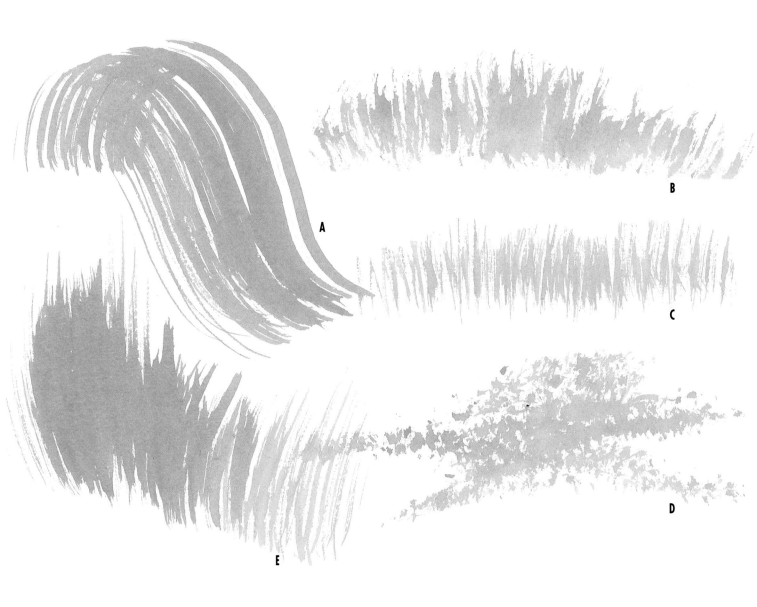

Basic Watercolor Techniques

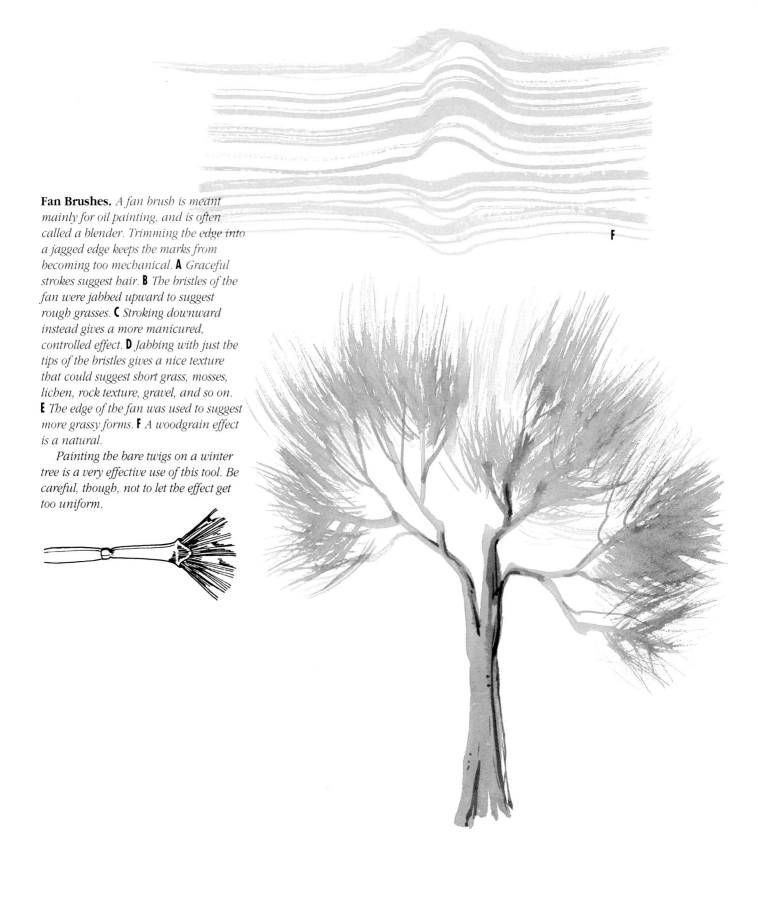

Fan Brushes. *A fan brush is meant mainly for oil painting, and is often called a blender. Trimming the edge into a jagged edge keeps the marks from becoming too mechanical.* **A** *Graceful strokes suggest hair.* **B** *The bristles of the fan were jabbed upward to suggest rough grasses.* **C** *Stroking downward instead gives a more manicured, controlled effect.* **D** *Jabbing with just the tips of the bristles gives a nice texture that could suggest short grass, mosses, lichen, rock texture, gravel, and so on.* **E** *The edge of the fan was used to suggest more grassy forms.* **F** *A woodgrain effect is a natural.*

Painting the bare twigs on a winter tree is a very effective use of this tool. Be careful, though, not to let the effect get too uniform.

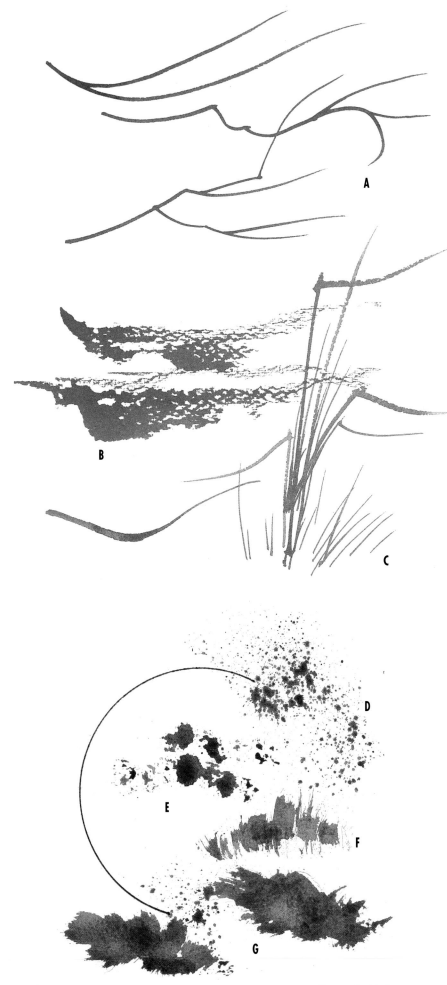

Riggers and Stencil Brushes. *Riggers and stencil brushes may look odd, but you'll find them indispensable for many uses. Here, blue was used for rigger lines, and burnt sienna, for marks made with a stencil brush. An old toothbrush might be your favorite tool instead.* **A** *Notice the nice, uniform, sweeping lines that are possible with a rigger or liner brush. Use them to suggest bare twigs—the line fairly dances as you change direction.* **B** *The side of the long rigger bristles produces a creditable dry-brush effect.* **C** *Long, weedy grasses look natural painted with a rigger.* **D** *A favorite use for the stencil brush—spatter. Use this to suggest texture in many applications. Try it for old boards, a sandy beach, rough soil, or sparkles on water. It gives the feeling of texture without the temptation to overwork.* **E** *More stencil brush; you may prefer a toothbrush or stiff-bristled brush intended for use with oils for this. Here the artist has jabbed with the ends of the bristles.* **F** *An upward stroke gives the feeling of rough grasses.* **G** *You can even paint with your stencil brush just as you would any other, for rugged effects; this effect would have worked well for pine boughs.*

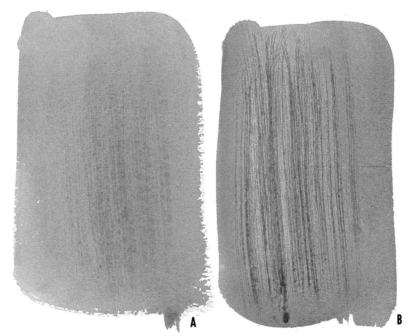

Try running the end of your thumb over the bristles to make the spatters fly. Other artists use an old pigment-loaded toothbrush run over a piece of screen wire, but some find that effect a bit too regular. Clump your spatter rather than making even droplets all over an area; it's more interesting and looks more natural to have some variation (top illustration, lower right).

You can also use clear water to spatter into a wet wash (upper left) *for* variations in texture. Blot with a tissue to play up the blotched effect.

Spatter color into a wet wash for softer effects, and continue to spatter as your wash dries. Blot here and there to ensure a variety of values.

Utility Brush. *This next brush requires a bit of explanation; it's a small, brass-bristled brush used for cleaning your barbecue grill—look in your local hardware store for this handy tool. Some have a scraping edge that makes them doubly useful—you can lift or push paint around with the edge.* **A** *The paper was scratched before painting to bruise it slightly; the effect is very subtle.* **B** *When you scratch into a wet wash, you can get much bolder lines, as the paint sinks into the damaged paper fibers.* **C** *There's one possible use for the wire brush—falling rain. You might also use it to suggest grass, hair, woodgrain, or simply a nice texture in an abstract composition. Try crosshatching into a wet wash for a fresh look. Suggest a linen weave in a portrait subject's clothing. It's a handy brush.*

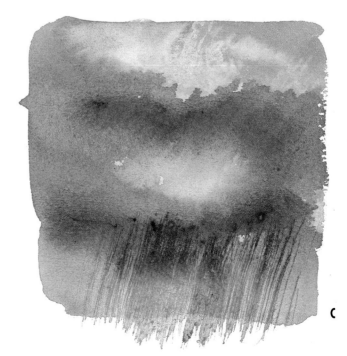

A

B

C

Chapter Two
TECHNIQUE
Using Your Materials Effectively

In this chapter we will explore differ-ent methods of applying color, as well as ways of removing color after it has been applied. Watercolor offers a remarkable range of painting tech-niques, many of which are demonstrat-ed here. You can probably come up with a few ideas of your own.

Four Basic Ways to Apply Color

There are four different methods of applying color to the paper: wet on dry, drybrush (dry on dry), wet in wet, and dry on wet. The last two techniques, in particular, make water-color really shine. Oil painters look with envy at the marvelous diffusion that these methods produce, and won-der how it was done. The magic of watercolor is that a few transparent washes, some strokes of color, and a little texture can conjure up a complete landscape.

No matter which technique you use, always remember to paint smart: Have plenty of color squeezed out on your palette, so you don't defeat yourself and your painting by scratching around for color that isn't there.

Wet in Wet

This is the most fluid way to apply color. It gives you the most transparent color, and the greatest diffusion of color. Wet in wet means the brush is well-charged with paint, and the paper is wet with water. In this technique, the paint flows off the brush and intermin-gles with the water on the paper in an uncontrolled manner. Wet in wet is perfect for skies or wherever you need large expanses of soft color. It's also ideal for producing an initial under-

Wet in Wet. *Here the paper was completely saturated with clear water. Then a combination of cerulean blue and French ultramarine blue was brushed in and allowed to run. By tilting the board, you can direct the flow of the colors somewhat to create interesting patterns of diffusion, and control the run.*

Wet on Dry. *With this direct method a brush wet with color is applied to dry paper. This variegated wash of several colors—cerulean blue, cobalt violet, and burnt sienna—would make an excellent underpainting for a barn wall, which would then be painted over to bring out the details.*

painting. Once it's laid down, you can paint into it dry on wet or, when the underpainting is dry, use direct painting (wet on dry) to define the subject. You can also glaze over a wet-in-wet wash that has dried.

Wet on Dry

Wet on dry is often referred to as the direct method, and is done just the way it sounds: a wet brush full of color is applied to dry paper. The color stays exactly where you put it, unless you soften the edge with clear water. Wet on dry is probably the safest of all ways to paint, because little is left to chance. However, it is also boring. You miss the glorious excitement of the wet diffusions that epitomize the luminous character of watercolor.

Drybrush

This technique is sometimes called dry on dry, as the brush has very little paint in it and the paper is dry. You usually hold the brush perpendicular to the paper and lightly draw across it. The brush leaves a small deposit of color on the raised grain of the paper, letting the white of the paper sparkle through. As in wet on dry, the color stays exactly where it is placed. This technique is typically used for texturing things like wood, and for areas of the foreground where extra detail is needed. It is also good for depicting sunlight sparkling on water. Drybrush works best on paper with some texture, such as cold-press or rough.

Dry on Wet

Dry on wet is the most useful method for the watercolorist, because it can be controlled without losing the freshness that makes watercolor so exciting. The name is a bit misleading, though; the brush is really damp, not dry, with a strong charge of color on the tip. The excess moisture has been taken out of the brush by touching the brush to a sponge or piece of tissue. The brush deposits color on the paper and soaks

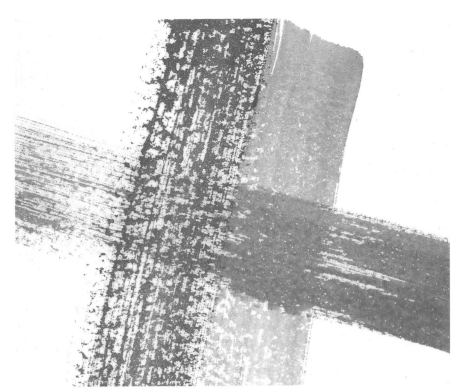

Drybrush. *Here the damp brush was lightly charged with color, and lightly drawn across the dry paper. The technique can be used for texturing wood or for texturing areas of the foreground.*

Dry on Wet. *A wash of cerulean blue was laid on the paper. While it was still wet, a fairly heavy amount of pigment was picked up on one side of the brush. The other side of the brush was touched to a damp sponge to remove most of the excess water. Only then was the color side of the brush applied to the paper. You can see that the color stayed pretty much where it was placed, but still has soft edges.*

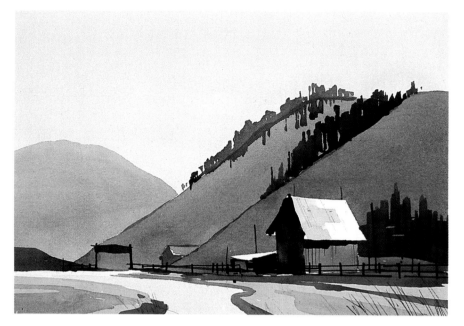

The Flat Wash. *This demonstration was done entirely with flat washes, trying to avoid any gradation at all. Do similar paintings to practice these three basic washes. Practice will really help you understand these methods of applying color.*

The Gradated Wash. *This demonstration was done entirely with gradated washes, starting with the sky darker at the top and gradually getting lighter toward the bottom. The hills were done the same way, darker at the top and lighter at the bottom. The foreground is just the opposite—lighter in the distance and darker toward you. You can use gradated washes to create a feeling of mystery and depth, as done here.*

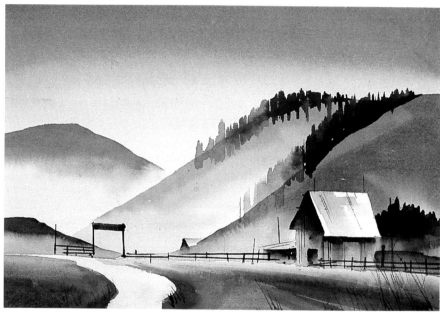

up some of the wetness from the paper, so that the color diffuses only a bit along the edges. With this method you can control the placement of the color, while getting very lovely soft edges.

Washes

There are three basic washes, all variations on the wet on dry technique: the flat wash, the gradated wash, and the variegated wash. They are illustrated here, along with a painting incorporating all three. A painting all done with the same type of wash would be very

boring. Consistency is great, but it's not everything.

Flat Wash

For practice, rule off three rectangles of about 5x8 inches. Let's try a flat wash, the simplest of the three. First, mix a large puddle of a dark color. Don't be stingy; mix enough color so you won't run out. Dip a one-inch flat brush into the puddle until it is fully loaded, but not dripping. Very lightly draw the brush across the top of the rectangle. Your board should be tipped at a slight angle so the color will run down. A bead of color

will form at the bottom of your stroke. This bead is important —the secret is to move this bead down and across the paper in an even value. Add more paint with each stroke, so there is an even deposit of color on the paper. When you reach the bottom of the rectangle, soak up the excess color with a thirsty, damp brush.

Gradated Wash

Now try the gradated wash. It starts the same way as a flat wash, with this difference: as you paint, you add more clear water with each succeeding

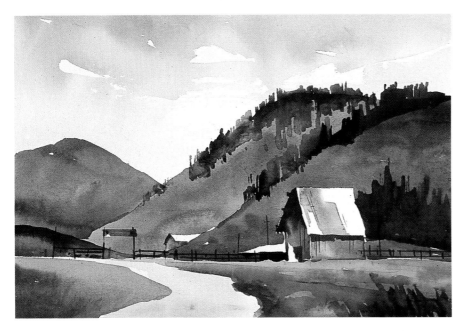

The Variegated Wash. *In this demonstration the artist tried to keep one value in an area, but also attempted to vary the colors in that same area. The sky was painted first using two colors—indigo blue and raw sienna. It was painted directly on dry paper, starting with the blue, working in some raw sienna, and then softening some edges with clear water. To paint the hills, three puddles of color were made on the palette—indigo blue, burnt umber, and raw sienna— attempting not to vary the value, while allowing the colors to mix on the paper. Remember, you get mud if you mix on the palette. You can see the play of warm colors against cool, and cool colors against warm, as well as the exciting intermingling of colors on the paper.*

As you may have noticed, using only one of the three basic washes for an entire painting gets very boring—for the painter and the viewer. Combining all three washes creates a more exciting painting. Here, a gradated wash— darker at the top left and becoming lighter at bottom right—was used for the sky. A variation of color was also used in the sky, combining the gradated wash with the variegated wash. To create a sense of distance and mystery in the hills, the artist used a gradated wash—darker at the top and lighter at the bottom. This little painting has more interest because of the variety achieved by using a combination of washes. Remember, variety is the spice of life.

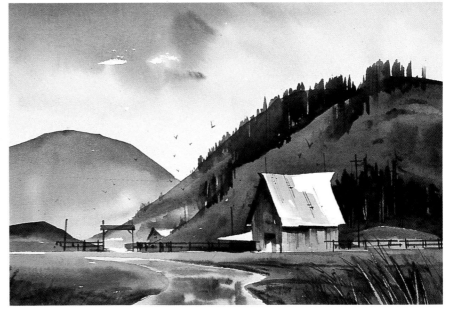

stroke, until there is only a bead of clear water at the bottom. The color should blend gradually from full intensity at the top to clear at the bottom. With all washes—you take what you get the first pass. You can't go back and "correct" a wash without disturbing the even deposit of color already on the paper. Luckily, there are few in-stances when you would want a perfectly even flat wash or gradated wash.

Variegated Wash

The variegated wash is probably the most important to learn, because it's the most useful wash. Mastering it will take you well on your way away from muddy colors and toward colors that really sing. The use of variegated washes keeps a painting from being boring. In fact, a good rule to follow is to vary your colors every two inches or so. Applying color with no variation isn't the smart way to paint.

Start with two colors, and then try it with three or more. First, mix separate puddles of color on your palette and, starting at the top of your rectangle, pick up one color and lay it on the paper. Rinse the brush and pick up another color, laying it where you left off with the first color. Keep doing this all the way down the rectangle, and you will get a beautiful interplay of colors diffusing into each other. It's important to mix the colors on the paper, not on the palette.

A large variegated wash makes a great underpainting. Once the wash is down, you can paint dry on wet for soft but controllable edges, or you can wait until the wash dries and paint over it using other techniques.

Experimental Methods

Many students avoid making bold statements when they paint, because they're afraid of making mistakes. The result is a pale, textureless, rather bland-looking painting. Be willing to take risks when you paint, once you've achieved some mastery of the fundamentals of applying color first.

It's fun to experiment with different methods of texturing watercolors. There are no rules on the subject, so you can let your imagination run wild. Who knows? You may be the one to come up with something unique.

The following pages will show you some of the many ways to spice up a painting by adding texture or by lifting out areas. It's impossible to cover all of the creative methods for texturing and lifting in one book, so we've tried to choose examples that illustrate as many as possible. Most of the methods of texturing and lifting were developed by the "California School" of watercolor. Rex Brandt and Robert Wood are considered by many to be two of the best artists of that school. Study their paintings if you want to learn more about these techniques.

Using these methods of texturing and lifting judiciously can elevate a painting above the ordinary. Using too many methods in one painting can make it look gimmicky. *Know when to say when.*

Liquid Frisket. *If you want to paint a nice, juicy sky in back of a complicated subject, block out the subject area with liquid frisket. Here's a tip to make it easier to clean the frisket out of the brush when you're finished. Wet your brush and put some soap on it before you pick up the frisket. Use liquid frisket only when absolutely necessary, because it leaves hard edges on the painting.*

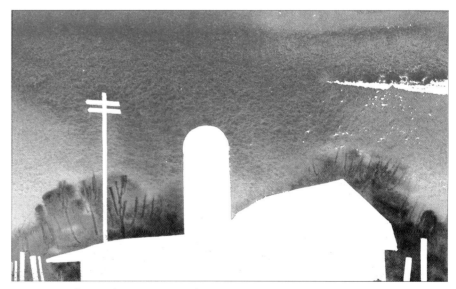

Removing the Frisket. *Be certain the painting is completely dry before using a pickup to remove the frisket. You can buy a rubber cement pickup in an art supply store, or make one yourself by pouring about a tablespoon of rubber cement on a clean, flat, nonporous tabletop. Let it dry and ball it up with your finger. If you don't use a pickup, chances are you will smear the colors.*

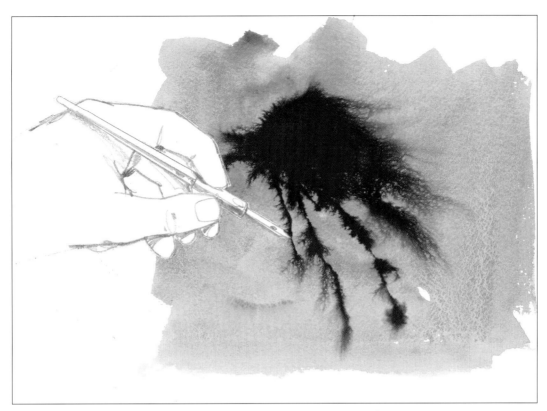

India Ink. *Some very interesting effects can be achieved by dropping India ink into wet color. You can also use a crow quill pen to draw lines into the wet color. Control the dispersion of the ink by controlling the wetness of the paper. The drier the paper, the less the ink will diffuse.*

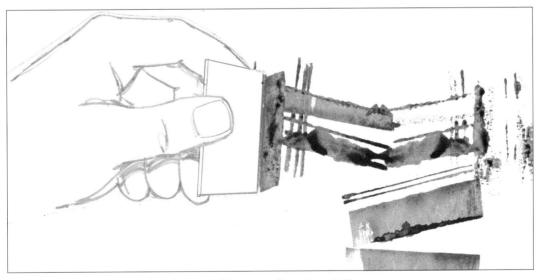

Stamping. *This sketch shows stamping with a piece of mat board. There are many things you can stamp with: a razor blade, an old plastic credit card, or anything with a similar edge. Stamping gives you a different feeling than you'll get with a brush—it seems to have more character and texture. You can use stamping to indicate the boards on a barn, fence posts, telephone poles, and similar subjects.*

Wipe Outs. *In this example the area to be lifted out was masked with artist's masking tape. After the area was masked off, a small natural sponge (cleaned and squeezed) was used to vigorously rub the area. Then it was blotted with a tissue.*

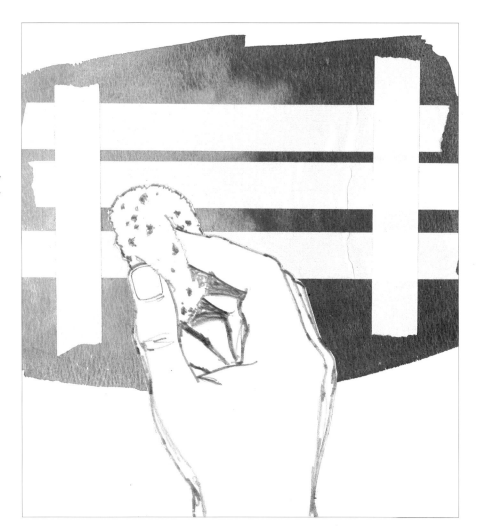

Remove the tape after your wipe out has dried and you should have a nice clean lift. This lift was done on 140-pound Arches cold-press. Paper lifts done on Crescent watercolor board will lift much easier, and will be much whiter. The paint rides on the surface of the board and doesn't soak in, as it does on the paper.

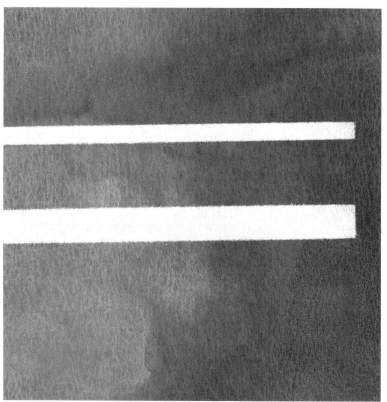

Basic Watercolor Techniques

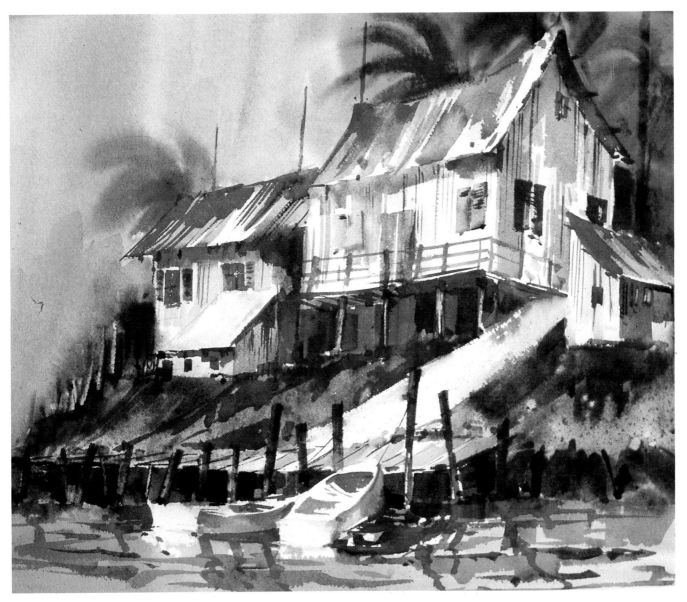

This painting illustrates some of the techniques we've just discussed. The path is a good example of wiping out, and the pilings on the pier were done by stamping. The artist felt these techniques were right for the subject matter. You won't use every special trick you know in each painting; it's more important to know when to use the trick that will create the desired effect.

A Day in Hope Town
20" x 24"
Al Stine

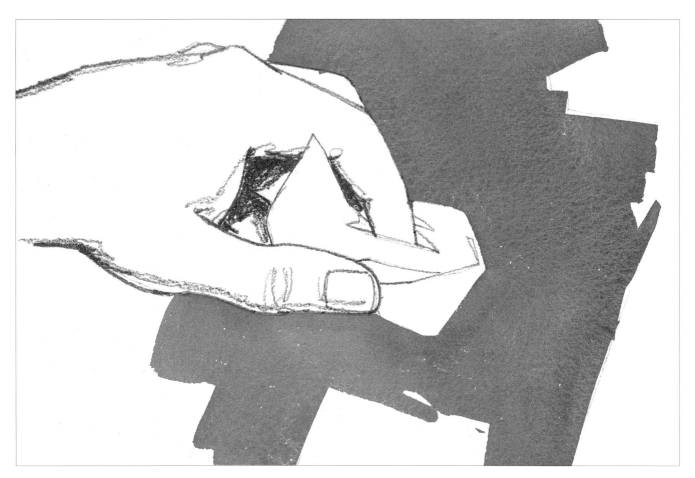

Lifting with a Tissue. *Lifting is an excellent way to texture or modify the value of a passage you have already painted. It's so useful, in fact, that you may find yourself painting with the brush in one hand and a tissue in the other.*

Now you can see the result of lifting. Experiment with lifting to see what effects you can create. Don't rely on dry tissues; try damp tissues to see the different results. (Damp tissues work well for clouds, for example.)

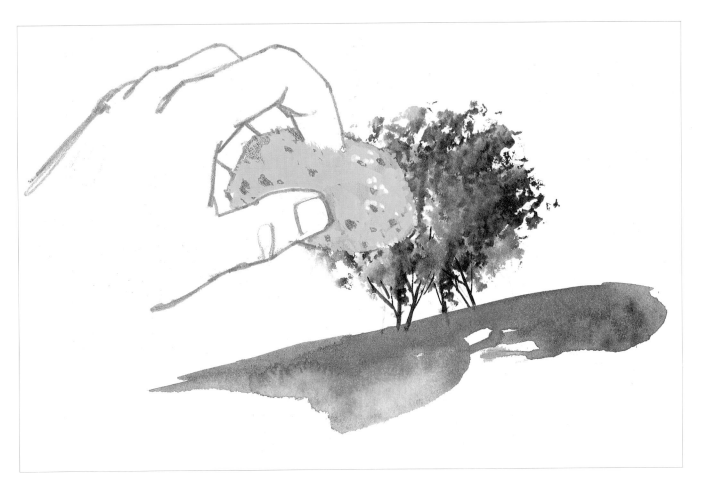

Sponge. *A small natural sponge comes in handy for indicating leaves on trees, especially the outer leaves. It's also good for doing ground scrub, especially for sagebrush.*

Blotters. *The kind of blotter you buy at a stationery store is good for lifting areas that are wet, or even just damp enough to be absorbed by the blotter. Blotters may be used for lifting roof areas and other similarly shaped areas to reclaim whites.*

Plastic Wrap. *To create texture in this example, the area where trees are to be added has been painted with fairly heavy pigment. A piece of plastic wrap was placed over the still-wet paint.*

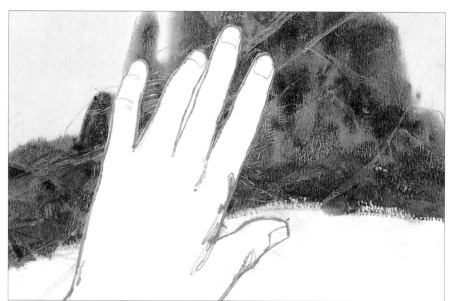

If you wait until the colors are completely dry to lift the plastic you will get sharp and crisply defined results. If you move the plastic before the colors have dried, the effects will be more diffused. Try it both ways; you'll like the results.

Basic Watercolor Techniques

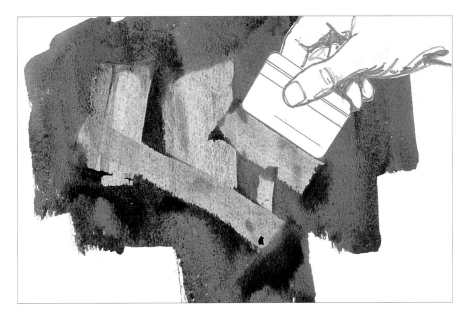

Scraping Out. *After doing an underpainting, a credit card was used to scrape away areas. You can also use razor blades, cardboard, and many other items. Scraping out is especially good for texturing rocks, fence posts, mountains, and buildings.*

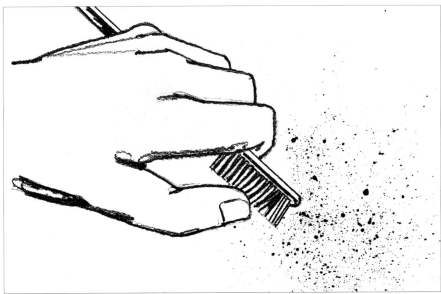

Spattering. *One of the most effective ways to spatter is with a toothbrush. Load the brush with color and, holding the brush upside down over the painting, pull your thumb across it. The spatter will fall on the painting. Be careful not to get too much liquid in the brush, or you'll get large droplets. Spattering is good for texturing foregrounds and old wood. It's also excellent for pulling colors together in an area. Make sure you spatter color while the paper is still wet or damp; the spatters will diffuse in the wet areas and bring the whole into harmony.*

Many of the techniques demonstrated in this chapter were used in this painting. You can see a little use of the sponge at the upper right. The masts were stamped on with a piece of mat board, as were some of the posts in the foreground. Some scraping was done with a razor blade in the foreground, and some with the squared-off end of a brush handle to get the two posts to the left of the stern.

Morning's First Light
13" x 20"
Al Stine

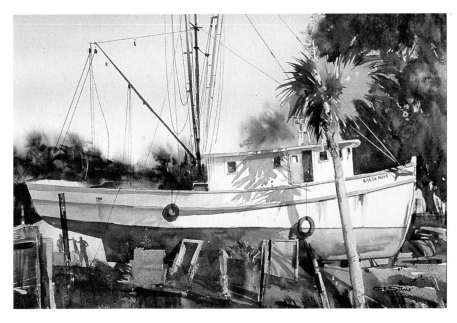

Brush Spattering. *Another method of spattering is to load a brush with color, then tap the brush sharply across your finger, as you see here, or across another brush. The spatters will be much larger than those made with the toothbrush. These are good for ground clutter in the foreground.*

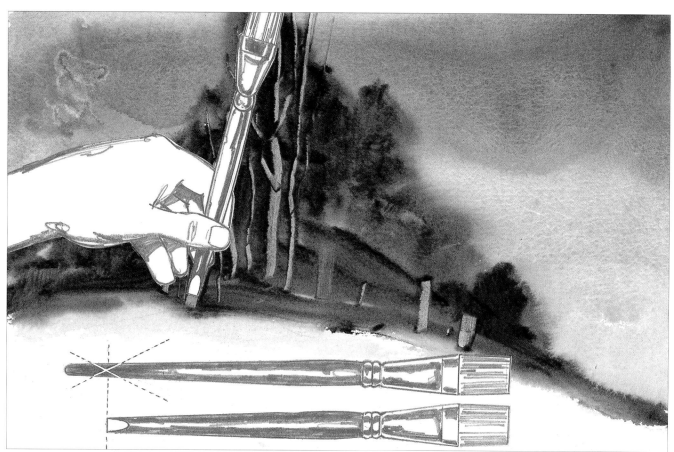

Scraping with a Brush Handle. *Scraping with the squared-off end of a brush handle is a favorite technique for indicating tree trunks, branches, fence posts, boards or barns, and many other objects. Some brushes come with prepared ends, but if you don't have one of these, simply take a knife and square off the end of a brush as you see here. You will find many uses for this technique.*

Basic Watercolor Techniques

Salt. *To add texture in this example, salt was dropped into an area while the underpainting was still wet. Regular table salt was used here, but some people prefer to use a larger grain salt such as sea salt or kosher salt. The salt can be sprinkled on, as you see here, or thrown on at an angle for different effects.*

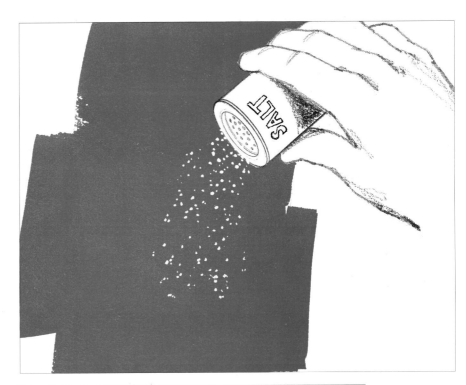

Here you can see the results of texturing with table salt. Don't get carried away; used sparingly in the right places, in the right amounts, salt can be very effective. If the grains are too close together, you get ugly, irregular spots, instead of the almost starry pattern you want.

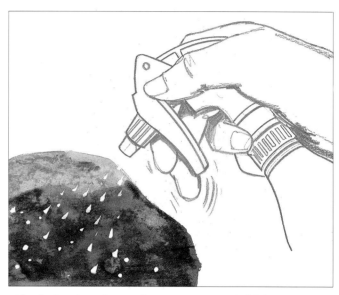

Spraying and Lifting. *It's possible to get wonderful color blends by spraying water back into your painting and lifting the rewetted areas with a tissue. Although we're creating rocks in the picture, you also can use this method to make trees, grass, or even to alter your skies. Here, an area that would be a rock has been painted with quite heavy color, using burnt umber, burnt sienna, Winsor blue, and a touch of olive green.*

After letting the colors set for a minute or so, hold the spray bottle above the areas and spray droplets into the color. Practice will help you determine the proper time interval before using the spray.

After you spray, lightly lay a tissue over the area. You may use a fingernail to score a mark on the tissue or press a little harder with the backs of your fingers in places. The feeling for what and how much to do will only come with practice.

Lift the tissue straight up from the painted area and, behold, you can get the most beautiful colors for rocks. You can work back into these areas after they're dry to indicate cracks or shadow planes. It's also used for doing background forests.

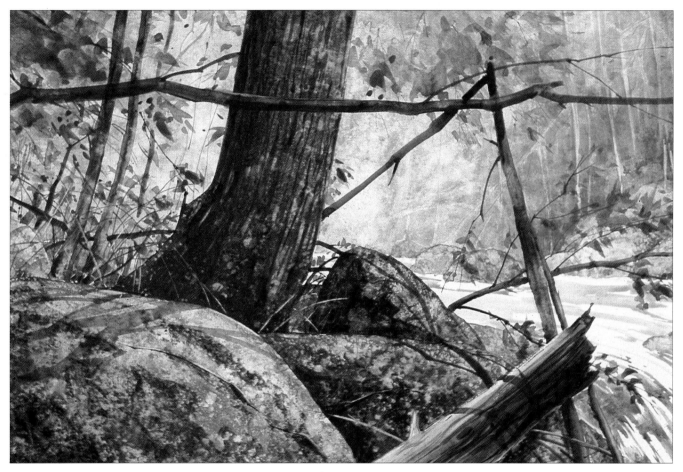

Here's a finished painting in which you can see the beautiful effects of the spray-and-lift method. This is the Cranberry River in West Virginia.

Mountain Mood
20" x 28"
Al Stine
Collection of Mrs. Alyse Hallengren

Chapter Three
USING COLOR
From Basics to Professional Color Secrets

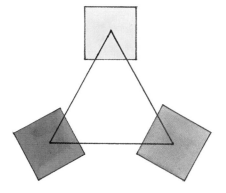

Primary Colors

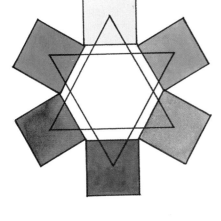

Secondary Colors

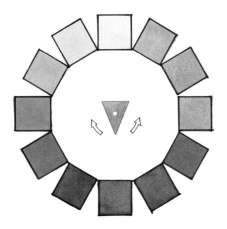

Complementary Colors

Much research has been done and many books written on the subject of color. However, what matters most is how much of this information you can remember—and have at your disposal—when you are excited and in the creative process of painting. Here is some simple information you can use in your work.

Color and Value

There are three dimensions of color: *hue, value,* and *intensity.* Hue is the term used to name a color. Red, yellow, green, blue, and so on, are hues. Value is the lightness or darkness of a color. Intensity refers to the saturation, strength, or purity of a color.

Primary Colors

The primary colors are red, yellow, and blue. We call these hues primary because they cannot be made from the combination of any other pigments.

Secondary Colors

The secondary colors are orange, mixed from red and yellow; green, mixed from yellow and blue; and purple, resulting from the mixture of red and blue. All of the other colors are combinations of the three primary colors and the three secondary colors.

Complementary Colors

Complementary colors are those located directly across the color wheel from one another. Yellow and purple, orange and blue, and green and red are examples of complementary colors. When complementary colors are mixed, the result is a neutral gray.

Color Temperature

When artists talk about a *warm* or *cool* color, they are referring to the quality of the hue. Generally speaking, the colors associated with fire—those centered around orange on the color wheel—are considered warm. Cool colors, on the other hand, are associated with ice, such as blue, green, blue-violet, etc. You may want to refer to the color "thermometer" if you have any doubt. To "cool" a color, then, you would add a color toward blue or green. To "warm" it, you might add red or yellow.

Value Range

Value range refers to the number of intermediate values we can mix between the darkest value straight from the tube and the lightest value

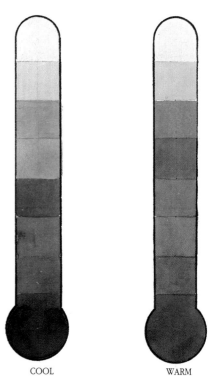

COOL WARM
Color Temperature

34

when mixed with water. For instance, yellow has a very short value range. Even if we used it directly from the tube, we could never achieve a value darker than 2 or 3. Alizarin crimson has a very long value range. It can be diluted to value 1, and in saturated form can be made to appear almost black.

Opaque and Transparent Colors

You will soon discover that some watercolor pigments are more or less opaque. In small accents it is possible to achieve a fair degree of opacity, and now and then an opaque color can be used to paint over a transparent one to achieve a veiled effect. However, as we are using it in this book, watercolor is a transparent medium.

Watercolor Pigments

Most professional watercolors are permanent, and are as enduring as oil pigments. In museums across the country you can see Chinese watercol-

or paintings that have lasted for hundreds of years, even though the fabric upon which they were painted has discolored with age.

We can assume that our pigments are chemically stable and permanent, but it is helpful to know a bit more about their properties.

As we discussed earlier, there are two kinds of watercolor pigments—*opaque* (sometimes called precipitating) and *transparent* (or staining).

Light rays penetrate the thick film of pigment deposited on the paper by staining colors and are reflected by the white of the paper, imparting a flow of color to the light (see below). The more that the white paper is allowed to reflect, the more luminous the effect.

When light is returned from an opaque color, it reflects only the pigment granules (below right). Before long, you may be able to recognize the opaque pigments from the way they flow onto the watercolor paper. They seem heavier, and are easier to manip-

ulate than the free-flowing transparent ones.

Differences in opacity or transparency and value range raise the question of how much, if any, black is contained in the pigment. There is no black or white in the spectrum; therefore, they are known as neutrals, along with all the other hueless grays. By knowing which pigments contain black, we can avoid them, or restrict their use to light value passages. With this knowledge we can select colors for clarity and brilliance.

The following pages describe the commonly used pigments. Almost every manufacturer makes good transparent watercolors. If you experiment with different brands of color, you will find some variation. See page 38 for some color comparisons between brands.

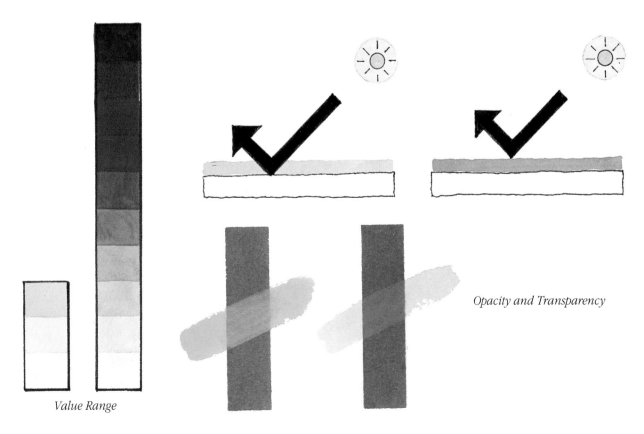

Opacity and Transparency

Value Range

PROPERTIES
of
WATERCOLOR
PIGMENTS

Pigment	Darkest Value	Opaque	Paper Staining	Transparent	Black Content
High-intensity Opaques					
Cadmium Yellow	2±	Very	Slight	No	None
Cadmium Orange	3±	Very	Slight	No	None
Cadmium Red	4±	Very	Slight	No	None
Vermilion	4±	Yes	Slight	No	None
Cerulean Blue	4±	Very	Slight	No	None
Cobalt Blue	5±	Yes	Slight	Slightly	None
Low-intensity Opaques					
Yellow Ochre	3±	Yes	Slight	No	Slight
Raw Sienna	4±	Yes	Medium	No	Slight
Raw Umber	6±	Yes	Slight	No	High
Burnt Sienna	6±	Partly	Medium	Slightly	Slight
Burnt Umber	8±	Yes	Slight	No	High
Low-intensity Transparents					
Brown Madder (Alizarin)	8±	No	High	Yes	Medium
Indigo	9±	No	High	Yes	Medium
Payne's Gray	10	No	Medium	Yes	Medium
Sap Green	6±	No	High	Yes	Medium
High-intensity Transparents					
New Gamboge	2±	No	Slight	Yes	None
Winsor Red	5±	Slightly	Medium	Yes	None
Alizarin Crimson	8±	No	High	Yes	None
Winsor Blue	10	No	High	Yes	None
Winsor Green	10	No	High	Yes	None
French Ultramarine Blue	8±	Slightly	Slight	Nearly	None

The Color Wheel

The color wheel presented here is arranged with yellow on top and purple at the bottom. This divides the wheel in half, with the warm reds on the left, and cool colors on the right. While red and orange are cooler than yellow, they are warmer than the blues on the right side of the wheel. However, all the colors become warmer as they approach yellow at the top.

The color wheel makes some very basic color relationships easier to see and understand. The three primary colors are located equidistant from each other. Any two primaries mixed together create a secondary color, which is placed between the two parent colors and opposite the remaining primary color. Thus, purple, which is the combination of red and blue, is opposite yellow, and so on. Since a secondary color contains two primaries, when mixed with its opposite all three primaries are present, and a neutral grayed color is created. This is true of any two colors opposite each other on the color wheel, since theoretically any two such colors together contain all three primaries.

If you wish to darken a color without it getting gray or muddy, adding its complement would be a poor choice, since that is the formula for a neutral gray. A better choice would be a color from the *same* side of the color wheel, not opposite. This is the key to rich, "brilliant" darks. By adding a transparent dark from the same side of the wheel, you can mix shadow colors that are lively and exciting.

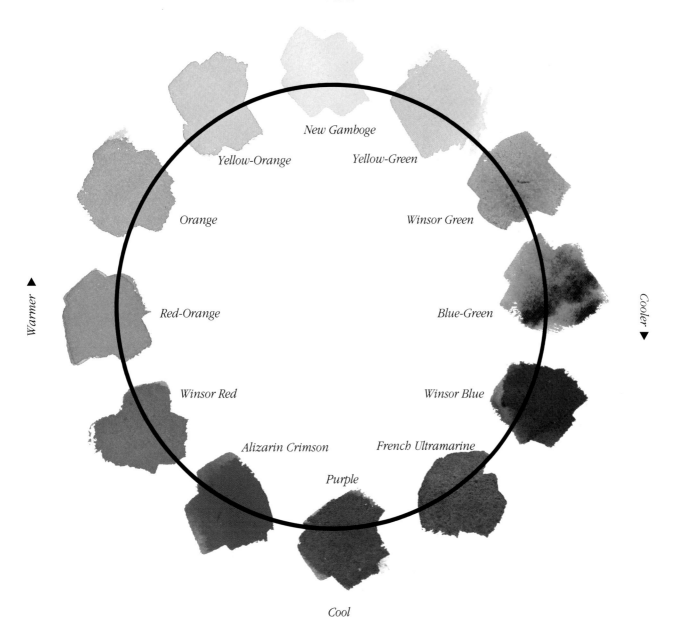

Warm

New Gamboge

Yellow-Orange *Yellow-Green*

Orange *Winsor Green*

Warmer ▲

Red-Orange *Blue-Green*

Cooler ▶ ▼

Winsor Red *Winsor Blue*

Alizarin Crimson *French Ultramarine*

Purple

Cool

Know Your Pigments

Perhaps the first step toward guaranteeing success with special effects is knowing your pigments. Knowing what to expect of your paints will allow you to use some very subtle tricks. Learn the properties of your pigments first, and you can employ confidently any new technique you want to try. Watercolor allows little room for the fainthearted.

Learn about all your pigments; their makeup and unique properties will help you make the best possible choice for the need at hand. Even the brand you choose can make a difference; it may be best to settle on one brand and stick to it, unless you can remember which company makes each particular pigment you prefer.

Take a while to become fully acquainted with each new tube you buy—and review the old ones while you're at it. If you haven't played with your paints up to this point, now is the time!

Brand Comparison

Comparing brands gives you an idea of the variety possible from brand to brand. Make a chart like the one below with the paints you have on hand to familiarize yourself with their differences. Notice particularly differences between the siennas and the blues shown here. Such diversity is not too surprising, though, when you consider that different companies choose different ingredients to make their colors. For example, sap green might be made of organic pigments in one brand and chlorinated copper phthalocyanine, monoazo acid yellow lake, and ferrous naphthol derivatives in another.

LIQUITEX GRUMBACHER
Cadmium Red Medium

WINSOR-NEWTON LIQUITEX
Burnt Sienna

HORADAM- WINSOR-NEWTON LIQUITEX
SCHMINCKE
Yellow Ochre

WINSOR-NEWTON LIQUITEX GRUMBACHER
Raw Sienna

WINSOR-NEWTON LIQUITEX GRUMBACHER
Burnt Umber

WINSOR-NEWTON GRUMBACHER
Cadmium Yellow Pale

WINSOR-NEWTON GRUMBACHER
Cadmium Yellow Medium

WINSOR-NEWTON GRUMBACHER
Payne's Gray

HORADAM- WINSOR-NEWTON LIQUITEX GRUMBACHER
SCHMINCKE
Ultramarine Blue

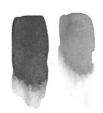

LIQUITEX GRUMBACHER
Phthalocyanine Blue

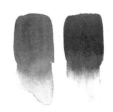

WINSOR-NEWTON GRUMBACHER
Cobalt Blue

WINSOR-NEWTON GRUMBACHER
Hooker's Green Dark

Pigment Composition

It helps to know a bit about the make-up of colors in general. When we refer to the earth colors, we mean yellow ochre, raw sienna, burnt sienna, and the umbers (as well as a few others) that are made from ground earths—mineral rich soil, clay, and so on. They are inorganic and less pigment-saturated. The mineral colors include the cadmiums, ultramarine and cobalt blue, etc., that are also inorganic, brilliant, and rather opaque. The carbon compounds are organic and staining; use with care. They include alizarin crimson, thalo blue, thalo green, etc.; they're often referred to as dye colors.

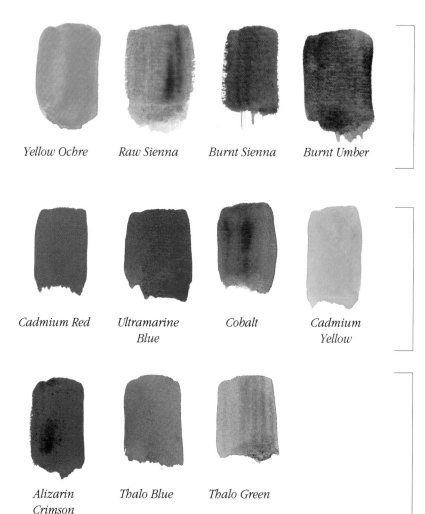

Yellow Ochre *Raw Sienna* *Burnt Sienna* *Burnt Umber*

Earth Colors. *(inorganic) less saturated*

Cadmium Red *Ultramarine Blue* *Cobalt* *Cadmium Yellow*

Minerals. *(inorganic) brilliant, sometimes somewhat opaque*

Alizarin Crimson *Thalo Blue* *Thalo Green*

Carbon Compounds. *(organic) staining, very strong*

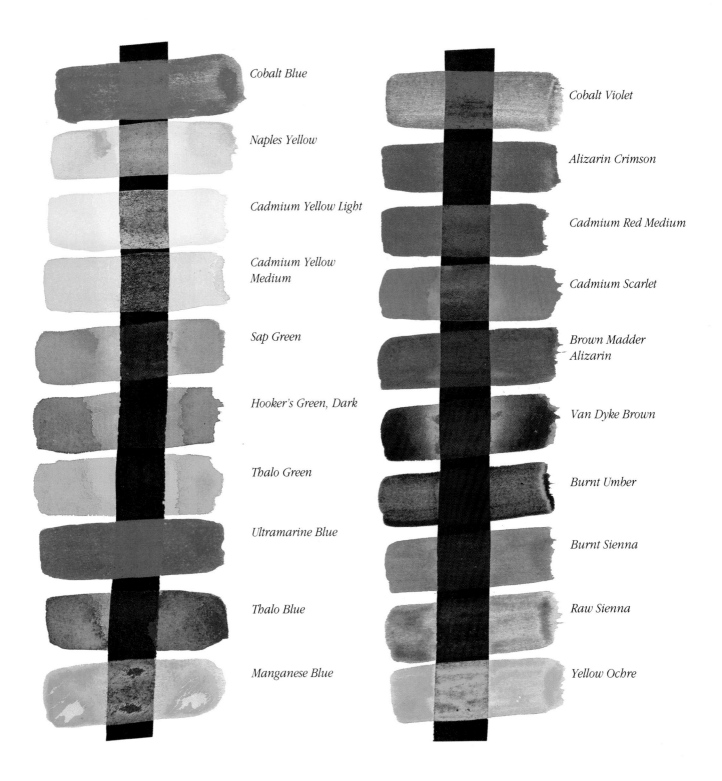

Cobalt Blue

Naples Yellow

Cadmium Yellow Light

Cadmium Yellow Medium

Sap Green

Hooker's Green, Dark

Thalo Green

Ultramarine Blue

Thalo Blue

Manganese Blue

Cobalt Violet

Alizarin Crimson

Cadmium Red Medium

Cadmium Scarlet

Brown Madder Alizarin

Van Dyke Brown

Burnt Umber

Burnt Sienna

Raw Sienna

Yellow Ochre

Color Transparency

Sometimes it is very important to know the transparency or opacity of colors. After all, if you want to lay down a transparent glaze, you'd be very disappointed to end up with a foggy veil instead. And when you want to cover something with a strong opaque, it's frustrating to have your overglaze disappear as if it had never existed. The cadmiums are quite opaque, and can be used as bright "jewels," touches of pure color, even over a very dark preliminary wash. Try this with alizarin crimson, and you won't see a thing. Make a handy chart of all your colors to help you see the transparency/opacity of each.

First, lay down a strip or two of black India ink and let it dry thoroughly. Then, simply paint a strip of each of your pigments over these black bars. Some colors will almost cover the black; some will seem to disappear.

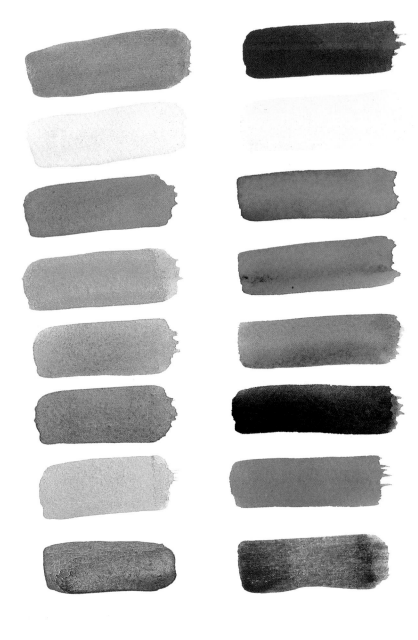

Inexpensive Pan Paints *Tube Colors*

Tube versus Pan Colors

Remember that the *quality* of your paints is just as important as the transparency, opacity, brilliance, or staining properties; perhaps it is more important. Paintings done with cheap paints may fade, flake, change color, or otherwise disappoint you. These samples compare an inexpensive set of children's pan watercolors with tube colors. The mounds of color were allowed to dry, then each sample was mixed with the same amount of water and the same number of mixing strokes. The difference is amazing, with comparable colors only in the lavender/purple area.

Palette versus Paper

Finally, keep in mind the difference in mixing your chosen pigments on the palette or on the paper; the contrast can be dramatic. If you want a smooth, homogenized blending for flat or especially subtle effects, mix on your palette. For more exciting and varied effects, try mixing directly on your paper. (Of course, you can mix more thoroughly than shown here—this is an extreme example—but the same colors were used in both rectangles.)

*Triad Scheme of
Secondary Colors mixed
on the paper*

*Same three colors mixed
on the palette!*

High-Intensity Opaques

These pigments have a very short value range. They are useful for bright accents and overpainting in small areas.

Cadmium Yellow. *A warm (toward orange) intense yellow. Can be mixed with cadmium red to produce light value skin tones. Very opaque. Can be used for bright accents.*

Cadmium Orange. *A pure, opaque orange. Mixed with Winsor blue or Winsor green results in a rich grayed green. Can be used to introduce reflected light into the shadow areas.*

Cadmium Red. *An intense (toward orange) red. Never a very dark value, even when used full strength. Useful in placing a "rosy glow" wherever needed.*

Vermilion. *Cadmium red may be substituted. It has most of the properties of vermilion, but is slightly less brilliant (and less expensive).*

Cerulean Blue. *A heavy, chalky pigment, greenish blue in character. Use to suggest gray hair and sometimes to cool facial areas. With yellow ochre it could suggest white in shadow.*

Cobalt Blue. *Close to a pure primary blue, and somewhat transparent. Combines well with other pigments to create beautiful secondary colors in light values.*

Low-Intensity Opaques

These pigments have varying value ranges, but used alone in dark values they appear lifeless.

Yellow Ochre. *Mixed with cadmium red, makes a good skin tone for light-value areas.*

Raw Sienna. *A glob of raw sienna on the brush, dragged across a wet area, leaves an uneven path that can translate into blond hair when laid alongside green or blue.*

Raw Umber. *Contains a lot of black. Use raw umber with phthalocyanine blue (in middle values) to create cool areas, such as around eyes.*

Burnt Sienna. *A burnt orange color, and a favorite of landscape painters. Mixed with blue, it creates wonderful grays. Mix it with alizarin crimson for warm dark areas.*

Burnt Umber. *Mixed with alizarin crimson, makes wonderful warm blacks for those small areas in complete shadow. Burnt umber should never be used alone, especially in dark values.*

Low-Intensity Transparents

These colors have a long value range. They can be diluted to pale delicate colors, but when used with less water, they appear very dark. However, like the low-intensity opaque colors, these pigments appear dull and lifeless if used alone in values darker than 6.

Brown Madder (Alizarin). *This is a beautiful, rich, red-brown. Combined with New gamboge, it is a brilliant substitute for burnt sienna.*

Indigo. *This blue-black pigment is sometimes useful as a very light-value glaze to cool "hot" passages. A real "garlic" color: a little goes a long way!*

Payne's Gray. *Mixed with Winsor blue, or laid next to burnt sienna, suggests black hair. Can become habit-forming, and overuse can result in gray paintings.*

Sap Green. *An intense (toward orange) green. Stains the paper, and is difficult to conceal. Use this color with raw sienna or raw umber to suggest a cast shadow.*

High-Intensity Transparents

These brilliant pigments—unlike low-intensity transparents—remain luminous at all value levels. They're useful for glazing, and mix well with other pigments to achieve lively darks. Remember, these pigments can stain other pigments, as well as the paper.

New Gamboge. *A brilliant, clean yellow. (Don't confuse this color with* gamboge, *which is dull by comparison.) Mixes well to make beautiful secondaries.*

Winsor Red. *Has great strength, but is not quite as transparent as others in this group. Tends to dry a bit flat. Can be used to intensify other reds.*

Alizarin Crimson. *A cool, very transparent red with a long value range. Mixes with burnt sienna or burnt umber to make beautiful warm darks, or with ultramarine blue for a luminous purple.*

Winsor Blue. *Another "garlic" color. A cool, transparent blue, beautiful by itself, but tends to dominate and should be modified with another color. Also called thalo or phthalocyanine blue.*

Winsor Green. *Cool in character and very intense. Try this color laid next to raw sienna to suggest silver jewelry. Also called thalo or phthalocyanine green.*

French Ultramarine Blue. *Can be considered a transparent or opaque pigment. Tends to dry lighter than expected. Combines with many pigments to make clear secondaries.*

Pigment Discoveries

For those among you with a color that has become a pet peeve—take heart. Try mixing all of the interesting variations you can to free yourself from your prejudice.

If, for example, your least favorite color is green, mix your greens from all the blues and yellows on your palette (the browns act as yellows, too). Then try altering the tube greens you may have on hand with browns, blues, yellows, or reds. You may discover a new-found love for your former pet peeve, and look forward to using it whenever possible.

These greens are made the old-fashioned way—with yellows and blues. Manganese, thalo, ultramarine, and cobalt are the blues; cadmium yellow, cadmium yellow light, and cadmium orange (!) are the yellows. There are any number of others, of course. Try Indian yellow, new gamboge, yellow ochre, or any other yellow (or blue) that you normally use. The point is to get acquainted with the colors you have.

Continuing to build on the green theme, tubed greens can be mixed with a number of other pigments for a fantastic variety. **A** is thalo yellow green, **B** is sap green, **C** is Hooker's green deep, and **D**, the most versatile of all, is that otherwise almost unusable thalo green. It may be too strident and acidic to use alone, but it's wonderful in mixtures.

One last green exercise. The palette of Velazquez included a green made with black acting as the blue in the primary triad (yellow ochre was the yellow, burnt sienna the red). Here, it's pushed a bit further with a quartet of subtle, olive greens.

E is the normal lampblack and yellow ochre. **F** was made with lampblack and cadmium yellow light; **G** is a lampblack and cadmium yellow. Finally, the brownest of our quartet—**H** is lampblack and raw sienna. Any of your pet-peeve colors can be mixed like this; green just seems to present more universal problems—and solutions.

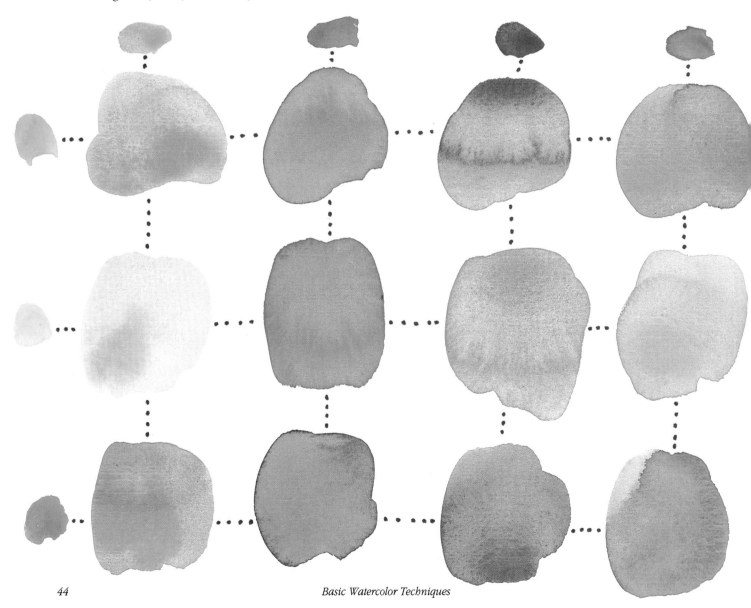

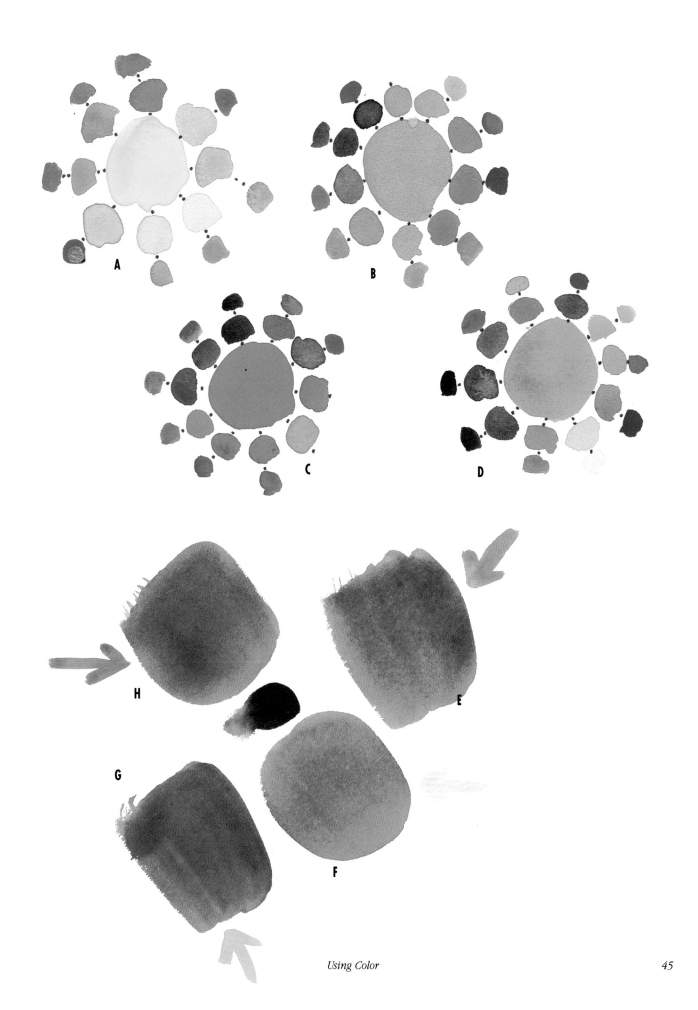

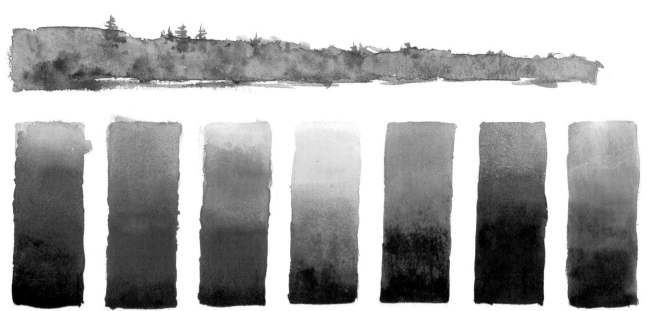

These top examples show two different approaches to controlling values as you paint. The band at top was created by first laying down a wash of neutral gray to establish the value. Then bits of color were dropped in—cadmium orange at the left, cerulean at the right—to give the impression of fall colors on a distant ridge. The seven panels beneath it were worked the other way. The hue was established first, beginning each panel with a different pigment of the limited palette. Then the value was changed by blending the pure color with vermilion and ultramarine.

Each of the seven colors of the limited palette mixes clearly with the next, remaining fresh and clear. This is important if you're to avoid muddy colors in your painting.

The Limited Palette

The downfall of many beginning painters is simply that they buy too many different colors. If you work with a limited palette—that is, a few colors that mix clearly and cleanly with one another—you'll find you can easily create a range of harmonious colors. The examples on these two pages were created using a limited palette of viridian, cadmium yellow pale, cerulean, ultramarine, cadmium orange, and vermilion.

Establishing Value

With the limited palette you plan first for value, which means that for color you establish the value by mixing ultramarine and vermilion to make colors of medium or lower value. If you want a number of areas of different colors to remain uniform in value, you can mix the desired value with ultramarine and vermilion, and add the approximate colors to reinforce each area. Thus your value will remain constant as you change color— an excellent way to pull the painting together.

The method of adding color after the value has been established is demonstrated in the example at top, which began as a middle value of neutral gray wash. A little cadmium orange added at the left end warms up the gray, while some cerulean added at the right end creates a cool gray. Then bits of cadmium yellow and orange, vermilion, alizarin, and viridian dropped into this wet wash give a hint of fall colors on a distant ridge. A few silhouettes of pines complete the illusion. The warmer gray and brighter colors on the left bring it visually closer, while the cool color on the right gives it distance. This effect has been achieved while keeping the value almost constant.

Before trying this method on a painting, do some experimenting on student-grade paper until you become

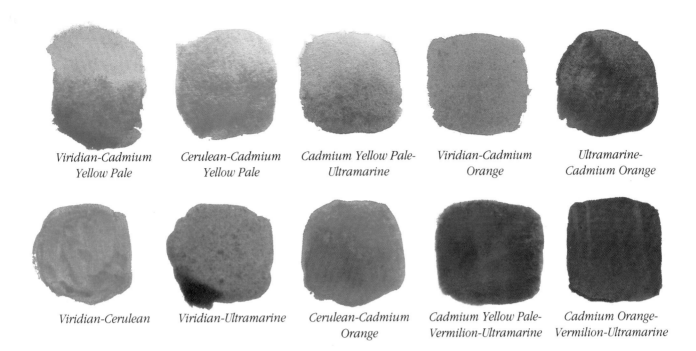

Viridian-Cadmium Yellow Pale	*Cerulean-Cadmium Yellow Pale*	*Cadmium Yellow Pale-Ultramarine*	*Viridian-Cadmium Orange*	*Ultramarine-Cadmium Orange*
Viridian-Cerulean	*Viridian-Ultramarine*	*Cerulean-Cadmium Orange*	*Cadmium Yellow Pale-Vermilion-Ultramarine*	*Cadmium Orange-Vermilion-Ultramarine*

Here you can see how easy it is to mix a range of colors with the limited palette. All ten are basically "green," but no two are quite the same.

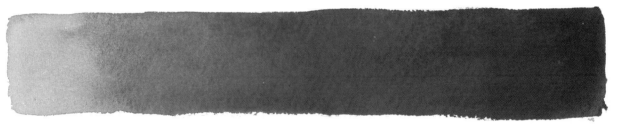

This wash of earth colors consists of pure cadmium orange on the left, mixed with vermilion and ultramarine to create the darker values toward the right.

familiar with what mixtures yield the values and colors you're looking for. Colors in the higher or lighter range of value, such as yellow, normally will be used pure (diluted only with water), while slight deepening of value will be achieved with the addition of a little other color, as mentioned earlier.

Changing Hue

The colors in the limited palette were chosen because they remain fresh and brilliant when mixed. The simple demonstration shown on the opposite page, bottom, illustrates the clear mix of each of the seven colors into the next. Since the cadmium yellow pale

has no red in it, it mixes readily with either green or orange, and remains fresh in appearance. Similarly, the green has no trace of red, so it mixes readily with yellow or blue, without losing brilliance. The ultramarine is a strong blue. It contains some red, which is useful; however, cerulean also is included in the palette, since it has more of the character of sky and water, allowing lighter blues with no trace of red in them.

A few examples of mixing greens are shown, top. In no case is viridian used as a pure color, only as an additive. Any variation can be achieved by changing the amount of each pigment

used. The final two spots were achieved by establishing a value by mixing vermilion and ultramarine before viridian was added. In this manner, any kind of green—warm (orange added) or cool—can be created in as deep a value as desired.

The wash shown at bottom demonstrates why earth colors are not needed. Beginning with pure orange at the left, the varying wash is controlled by the addition of vermilion and ultramarine to create the whole gamut of earth colors, down to the darkest value.

Chapter Four

DESIGN

Easy-to-Use Tips for Better Painting

All good paintings are done on the basis of good design. Effective design is seldom an accident. Artists spend hours doing thumbnail sketches before choosing one as a model for a finished sketch. Only then do they tackle the watercolor.

A design is the blueprint or pattern for the painting.

Principles of Design

Balance

If a picture is clearly balanced when we view it, we feel secure and satisfied. But if this stability is too obvious, we're bored. Most pictures are created with an informal balance, one in which the elements aren't mirrored top to bottom or side to side, as in formal balance. Informal or occult balance is more exciting, suggesting movement and spontaneity.

Balance or equilibrium is usually accomplished by mentally weighing areas of value, color, and texture against one another. Large light areas balance small dark areas. Placement of objects in a negative field can create balance if properly related in size and value. A small spot of pure color will be balanced by a larger area that has been diluted. Gaudy areas need to be handled judiciously, so that gray areas are

not overwhelmed. Balance means equilibrium of color, too.

Continuity

Organized movement or rhythm in placement of elements in a picture is called *continuity*. Like the repeated theme in a melody, continuity is usually established through repetition that is made interesting through variation and alternation.

Harmony

Harmony is the desired end result of all pictures. Every element should fit together in a unified whole. When colors, values, shapes, and textures hold their proper place in a picture, harmony is achieved; nothing needs to be added or taken away.

Emphasis

All areas of a picture should not have equal emphasis. To do so would be like having all instruments in an orchestra play at maximum strength at the same time. The result would be deafening, unsubtle, and unsatisfying. The eye, too, responds to variety. For a form to appear visually dominant, it must be juxtaposed with areas that are recessive. Good pictures depend on such variety.

Because of the asymmetrical placement of the barn, the design of Grandpa's Wagon *could be called* informal *or* occult. *The placement of the wagon and its reflection in the puddle help create a sense of balance by keeping the barn from becoming overpowering. The background details of barn, mountain, and telephone poles also contribute to this effect, creating a pleasant sense of balance.*

Imagine this painting with everything removed but the barn. Do you see how the design would seem lopsided? After you learn the principles of design, they'll seem like common sense.

Grandpa's Wagon
15" x 22"
LaVere Hutchings
Collection of
Dr. and Mrs. Denver Perkins

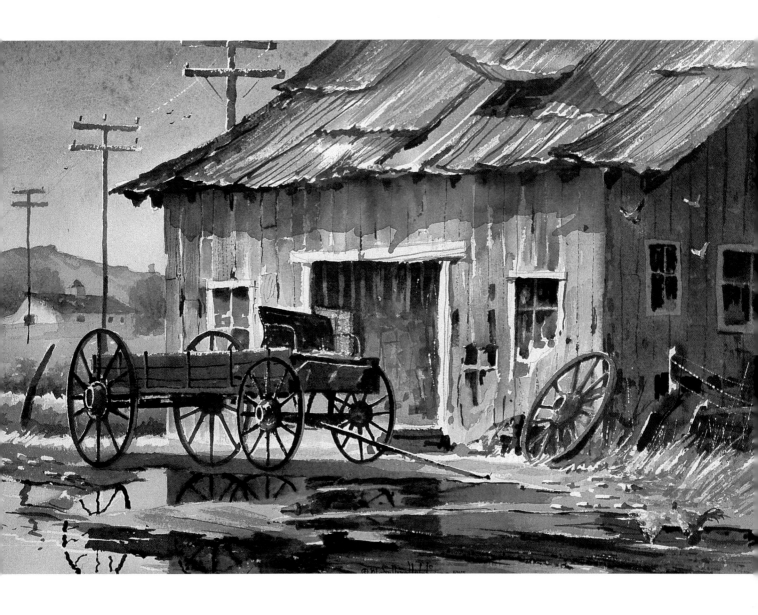

Negative Space

Negative space is the area in a picture not occupied by a (positive) form; it's the neutral background around a form. Looking for and using negative space is as important in designing as considering shape and proportion of positive forms. Here is an example of how negative shapes can be useful in planning the design of a picture.

Step 1. By creating three negative shapes that are not equal in the planned picture, three abstract elements are established to serve as a basis for the design. Try to keep these shapes unequal in size, dissimilar in contour, and yet in harmony because of the nature of the line.

Step 2. This skeletal structure can be the basis for unifying the composition.

The next step is to develop related, interlocking elements to provide counterthrust and movement.

Step 3. Finally, dark and middle values are added without destroying the flow and movement of the original negative shapes. The puzzle becomes more complex as the dark shapes begin to take over and compete with the white shapes. At this point, begin to move and adjust all the elements in the picture to achieve proper balance of positive and negative space.

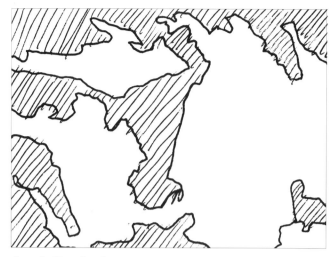

Step 1. *Negative shape*

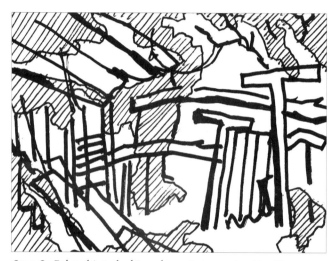

Step 2. *Related interlocking elements to create opposition*

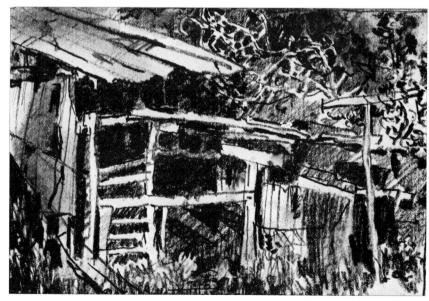

Step 3. *Dark and middle values used to unify picture*

A Value Scale

Making a value scale can be an exercise of lasting worth. The ability to see the tonal value of color is essential for the successful artist. A value scale is a great studio tool that can teach you this skill. The scale shows even steps from black to white. You can use it by comparing each of your colors to the value scale to determine where each color fits.

Following are instructions for creating a step-by-step gradation of value from black to white with five steps between. A color can be substituted for black if you wish, but stay away from yellow. It presents special problems because of its lightness.

Begin with a fairly large puddle of pure color. Paint in your darkest value—here the black at the bottom of the swatches. Then add a brushful of water to each succeeding value as you move up the scale. Sometimes a value can be lightened by wiping the water out of the brush, tipping the paper, and picking up the bead that forms at the bottom of the wash. While the wash is still wet, you can brush more of the mix into it. You also can use the point of a loaded brush with the same mix to stipple into a wet wash, if it needs to be darkened slightly.

Create a value scale. *You can create a value scale for any color by beginning with a puddle of pure color and adding a brushful of water for each succeeding color. Here we see a gradation of value from black to white.*

Designing with Wash Values

Step 1. It's important to plan how light or dark each area of the painting will be. Work out a pen or pencil sketch to serve as a plan for placement of shapes and values.

The first step in this picture was to wash in the sky tones, side of the building, and trees and foliage. Since no masking was to be used, all the white areas had to be left untouched. This was done by painting around them. The light source was from above, so most of the whites were on the tops of brushes, post, grass, steps, and roof.

Step 2. Next, a dark value was washed onto the sides of the house. The pine tree was added, but this tone seemed too dark. Some of the wash was lifted off with a damp sponge and tissues. Corrections can be made in watercolor, but they take care and practice. Additional tones were added to the house and boards and shingles on the roof. Some adjustments also were made in the background trees.

Finished Painting. As the undertones dried, more darks were added to the structure and, in particular, the foreground puddle. Finally, the people were added, along with the telephone pole and fence posts.

You can see by this example that if your sketch works in black and white, it has a good chance of success in color.

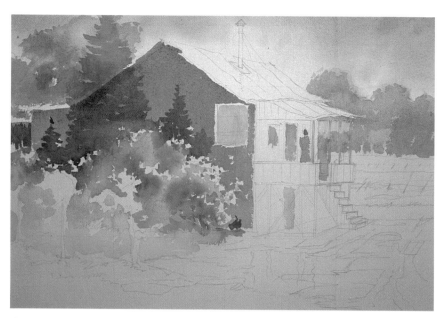

Step 1

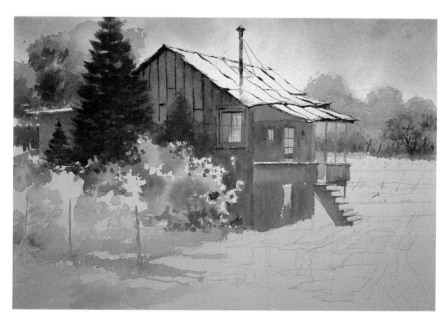

Step 2

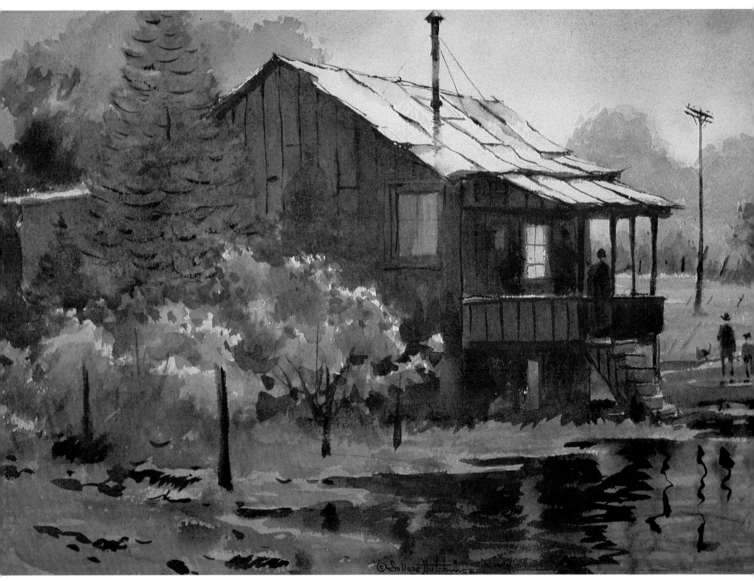

Old House in the Rain
22" x 30"
LaVere Hutchings
Collection of the Artist

Saving Whites

It's helpful to know where white areas will be before beginning a watercolor. If you look at these sketches for creating interesting value shapes, you'll see how carefully the white shapes were planned. You may want to leave extra white areas—knowing that they may end up painted—as a sort of insurance. It's nice to have the option of using white areas later on; it's easier to cover than uncover.

Masking is a procedure for saving critical whites, especially when more than one big wash will be used. Boat masts and rigging, figures, birds in flight, highlights on water, trunks, barbed wire, small pebbles, and other detailed subjects are good places to use frisket. (See page 22.) However, overuse of masking can become a crutch, and may even detract from an otherwise loose, interesting rendering.

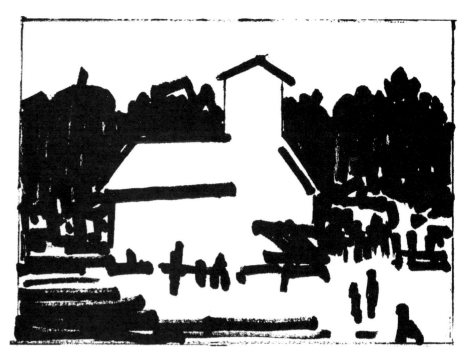

The basic design of Douglas Flat School *is the large light shape of the school set against the dark background of trees. The structure is the dominant element, but the figures add life and make the scene interesting.*

The placement of the figures was done to carry the observer's eye toward the schoolhouse. Notice how the movement from right to left is stopped at the left margin by the position of the horses (added in later) and vertical tree trunks; thus, the viewer's eye is turned back to the circle of interest.

Basic Watercolor Techniques

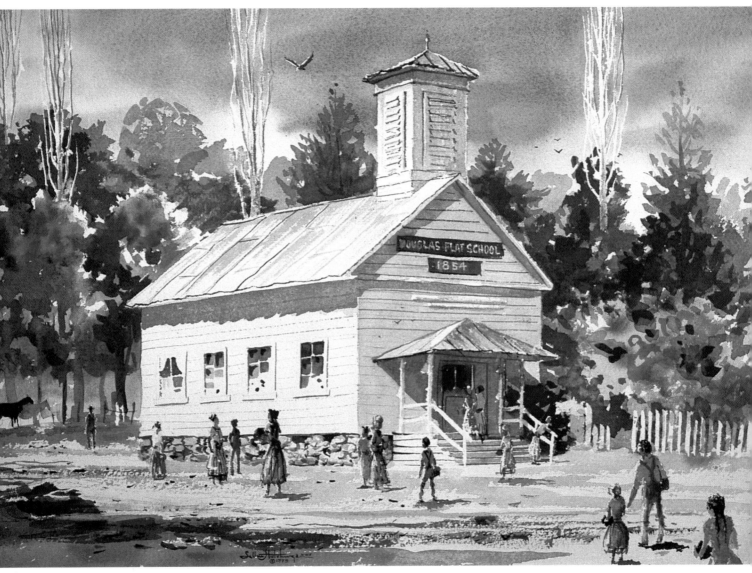

Douglas Flat School
15" x 22"
LaVere Hutchings
Collection of Grace and Owen Karstad

Chapter Five
LANDSCAPES
Painting the World Around You

andscapes are probably the most popular
painting subject. Maybe the beauty we see
around us inspires creativity. But painting a land-
scape can be confusing and difficult. To simplify
these complex scenes, separate the landscape into
its individual elements, and take a closer look at
how each is painted in watercolor.

Skies

Skies are exciting to do in watercolor. A sky must
be done rapidly with no second-guessing. Don't
go back into it and try to change areas (unless you
are working wet-on-wet and intend to mold some
passages). Save "failures," and use the backsides
for quick sky studies.

To capture beautiful, fluffy masses of cloud
accentuated by an infinity of intensely blue back-
ground, choose an area and begin with a brush-
load of clear water. (You'll have to work fast,
because it will change in three or four minutes.)

Step 1. Working on a dry sheet, generously wet
the edges and shadow areas of the clouds. Load a
large brush with ultramarine, to which a bit of
cerulean has been added, and dash in the largest
areas of blue, working up to the moist cloud
edges so that a soft edge results. Occasionally, stay
in dry areas so you can get small bits of hard,
ragged edges. Then, spot in a few blue "holes" in
the cloud mass, keeping the edges soft.

Step 2. Now mix a slightly warm gray, using
ultramarine and vermilion with just a touch of
cadmium orange. Put in the deepest shadow areas
of the clouds, starting at the lower soft, wet edges
where the blue sky begins, so that this will blend
readily. It is important to match the moist areas
with a similar degree of moisture in your brush as
you do this. Too moist a shadow wash will fan out
into the blue, while too dry a brush will pick up
blue, which will result in a hard edge or spottiness
as it dries. As you work up into the cloud areas,
dilute your gray with more water, and occasionally
brush into the dry area with a light touch to obtain
dry-brush edges of very pale shadow value.
Important: now leave it alone and settle for what

you have.

This procedure also can be reversed by paint-
ing the clouds first, then adding the blue sky last.
The difficulty here is that it is easy to spend too
long on the clouds, so that the edges may start to
dry before you can apply the blue.

Cloud Layers

Step 1. The use of large clouds at the zenith and successively thinner layers of cloud suggests distance, and creates restful horizontals for a peaceful farm landscape. The blue was painted with a large brush and a load of color—ultramarine with a bit of vermilion at the top, then pure ultramarine. Lower down, cerulean was added to the ultramarine, then cerulean was used alone and, finally, with a touch of cadmium yellow pale to give a greenish cast near the horizon. Some of the edges were softened with a damp, clean brush.

 Step 2. The lower surfaces of the clouds received a wash of gray, deepening toward the bottom. Some edges were soft, some dry-brushed, so that soft, hard, and dry-brush or rough edges existed together, giving variety. Lastly, a simple fall landscape was painted on the horizon.

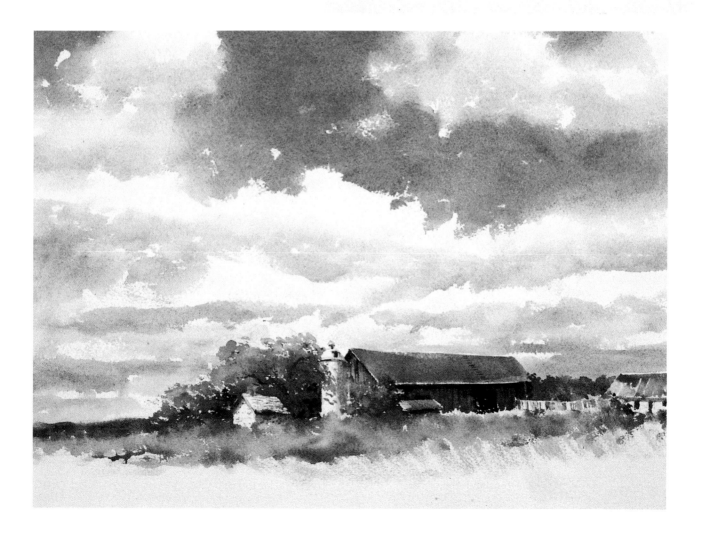

Breaking Ice for the Edwin Gott, *at right, suggests the mood of a cold winter morning. The sky was glazed first with a warm wash of cadmium orange and vermilion toward the horizon. Later, the lavender clouds were added to the redampened sky. The tree branches and the slanted smoke of the tugs helps suggest the action of bustling tugs breaking the heavy ice.*

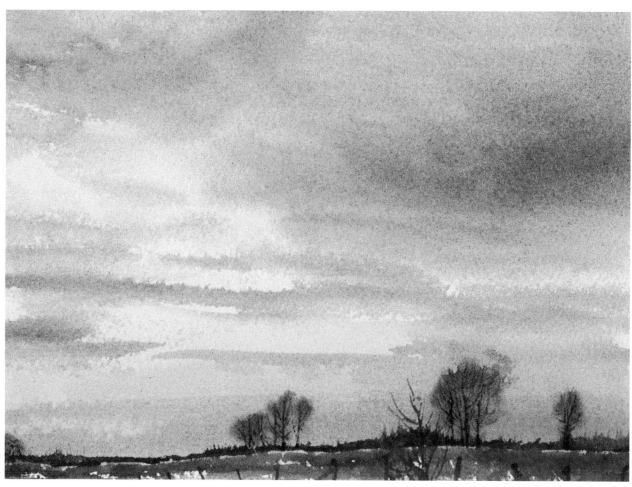

Basic Watercolor Techniques

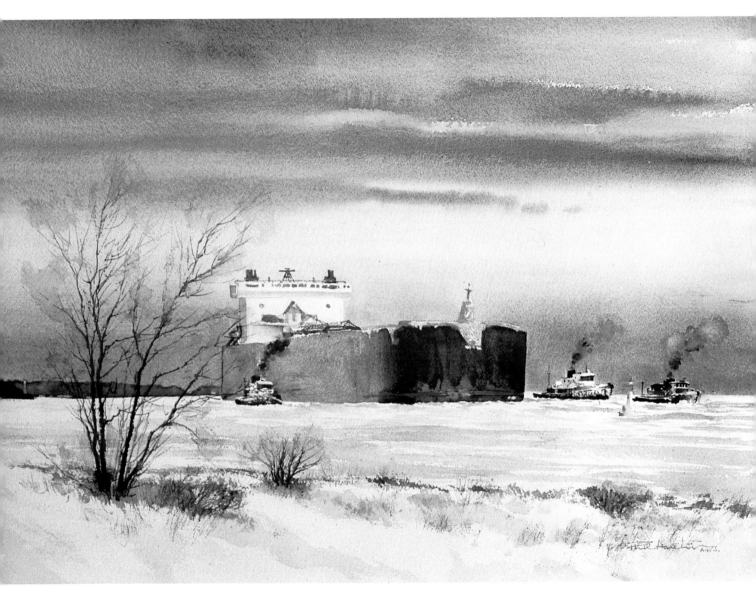

Morning and Evening Skies

Step 1. (Top left.) This second approach works well for a morning or evening sky. In the first stage a thin, wet wash of cadmium orange was laid over the entire area, deepening it toward the horizon with more orange. The largest cloud in the upper right was put into the moist sky with a slightly purple wash (ultramarine with a bit more vermilion than for a neutral gray).

Step 2. (At left.) The purple wash was also touched into the wash along the horizon to suggest distant cloud cover or haze. The sky was then allowed to dry completely.

The above-mentioned cloud wash was used again, but first the dry sky was misted with clean water from a spray bottle and allowed to stand until the shine disappeared from the surface. The cloud masses were laid in, starting at the top and working down. The middle area happened to be a little drier, which was fortunate, since the long strings of clouds in that particular area came out practically dry-brush, giving more definition and a change of pace. The area below them was still moist enough for those clouds to spread more, giving softness to the distance. With care, a hairdryer can be used to speed drying in desired areas.

A little warmer wash (orange added) formed a blur for the treetops. Brush handling gave them character. Finally, the foreground, skyline, and trees were completed.

Breaking Ice for
the Edwin Gott
21 1/2" x 29"
Phil Austin

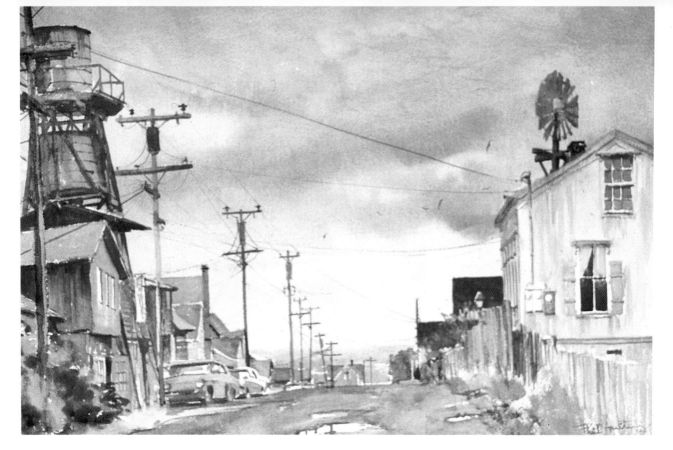

The stormy sky is clearing here. The complex pattern of surrounding poles, water tanks, windmill, and buildings is held to a series of relatively simple contrasts, the darkest spot being roof silhouettes against the dark sky.

Rainy Alley, Mendocino
14½" x 21½"
Phil Austin
Collection of Dr. and Mrs. Paul Swade

Stormy Sky

Step 1. In this stormy sky the first wash was applied very wet, so that considerable molding of values could be done. The extremely light areas were avoided, then moistened with clear water, blending all edges. In the upper sky a mixture of mostly ultramarine and cerulean, with just a small amount of vermilion, was used. In the lower sky, cerulean with a small bit of cadmium yellow pale was used.

 Step 2. At this point either of two methods is a possibility. You can go into the wet wash with a brushload of a rich mixture of ultramarine and vermilion, and form the tumbling clouds and the drippy ones just above the light horizontal. Or, if you prefer better control, allow the first step to dry completely. Then mold the clouds, do the lower ribbons of dark, and gently mist the entire sky with a little clear water, so that soft blending occurs. When all is dry, the little farm scene below can be put in to complete the mood.

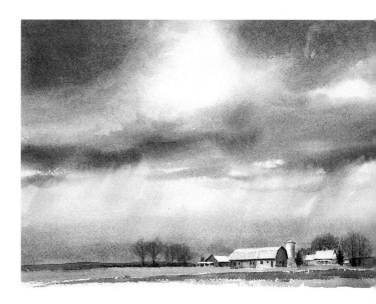

Winter Sky

Step 1. In this final sky demonstration, a mixture of ultramarine, cerulean, and vermilion creates a cold winter sky. A flat was laid down, carefully painting around the building area with its snowy roofs. A small amount of alizarin was laid into the damp wash near the horizon. While the wash was very damp, cadmium orange was also dropped in for the color of tree limbs and branches in late night. Then, the surface was lightly marred with a slender brush handle to indicate the tree forms in detail. As the washes dried, brush-handle work on the main trunks and limbs left a light line, indicating light falling on these areas. Some portions of bare roof were indicated, as well as snow shadows.

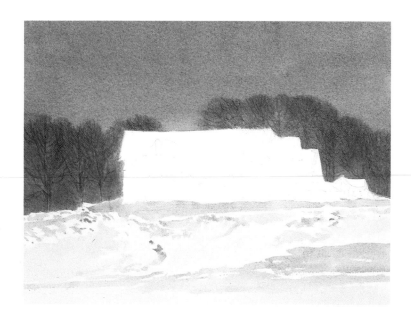

 Step 2. In this second step, a dark horizon was added on the left and the buildings were completed, as were the snow shadows, fence posts, and weeds in the foreground.

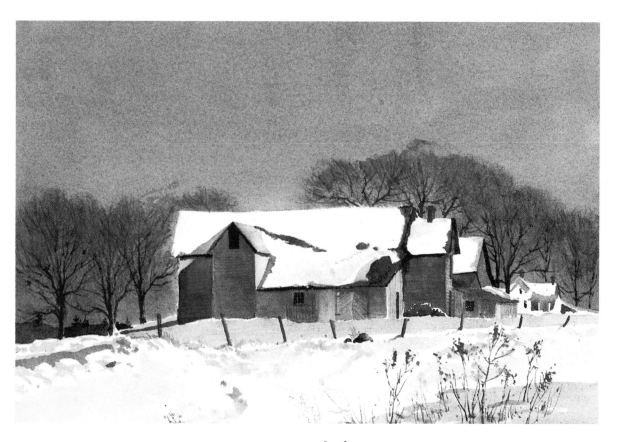

Trees and Foliage

For the landscape artist, learning to paint trees and foliage can be as essential as learning to paint skies. Painting the many varieties of trees and foliage could keep you busy for years. Notice how other artists have handled this challenge: Jamie Wyeth, perhaps, or John Pike, or one of the wildlife artists. Artist/naturalist Keith Brockie carefully delineates textures with a wonderful freshness.

How you paint a tree depends on the type of tree. An oak is rugged and gnarled; a willow, graceful. In deep woods where trees must compete for available light, younger ones may rise for many feet without branching—they may have had to stretch for sunlight. This makes them smoother and straighter than old trees that received more light before the forest filled in around them, and that are naturally branched or gnarled, heavily textured even to the roots. Look for these differences in texture and form and accentuate them.

Roots also make interesting subjects. Normally hidden under the soil, where they may spread as far in any direction as the leaf canopy itself, exposed roots give us a sense of the strength and tenacity of these largest of plants.

Some trees have seemingly defied gravity by their clinging roots, or have given up their hold on an arid forest ledge to expose great, twisted root systems that resemble beached and rigid octopi. These make terrific painting subjects, and are always available, too.

Bark Studies

You may want to make a series of sketches or small watercolor studies of different bark types to keep on file. Any good field guide on trees will help you identify the tree you've chosen as a subject; make a few marginal notes as to season, tree size, color, and any other details you happen to notice. Were there lichens or moss on the bark; engraver beetles or other tunneling creatures; shy moths hiding under loose bark; woodpecker or sapsucker holes? These notes may seem incidental to painting, but they familiarize you with your subject, which helps you to better depict it. They will also serve as memory jogs to bring the image to mind more clearly when it's time to paint. You will begin to *know* your subject in a much deeper way.

This little sketch is a study in contrasts: rough and smooth, warm and cool, massive and spidery, twisted and straight. It was done on a watercolor postcard stock and sketched with a dark-colored pencil. Watercolor washes were added later.

Uprooted
4" x 6"
Cathy Johnson

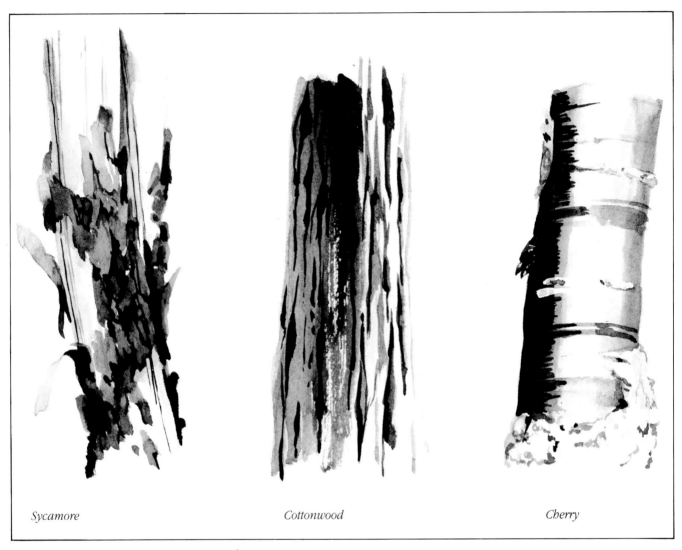

Sycamore *Cottonwood* *Cherry*

When painting a close-up, almost portrait, of a tree, you won't be satisfied with a generic bark texture. You'll begin to notice more than that. Is the tree a sycamore, with its pale underbark and flaking surface, or is it a stretched-tight-looking beech tree? Does it have deep furrows like a cottonwood, or the glossy look of a cherry tree? This sketch represents only three of the myriad possibilities. Try a combination of techniques here; a wet-in-wet underwash and an almost dry-brush overwash for texture can be very expressive (the cottonwood was done this way). Or build successive washes, as on the sycamore bark. Just be sure to notice the differences, and tailor your technique to match.

Demonstration: Leafy Tree in Autumn

A particularly interesting study for the landscape artist is the tree in autumn foliage. Look for trees with characteristics all their own, and seek the best way to interpret them. Here are some ways you may find effective.

When painting foliage, look for the pattern of light and dark values. Then, begin with the areas of most light, painting those areas only. Leave a dry surface on which to add the middle and dark values. In this manner you can hold any desired shape or definition, and you can touch one wash to another for blending.

Step 1. This spreading tree is a good one to start with. Its outspread top catches a lot of light, which is put in very wet on the dry surface.

Step 2. Now the second value is put in, again very wet, so it blends readily in several places. Again, the paper is still left dry for the third value.

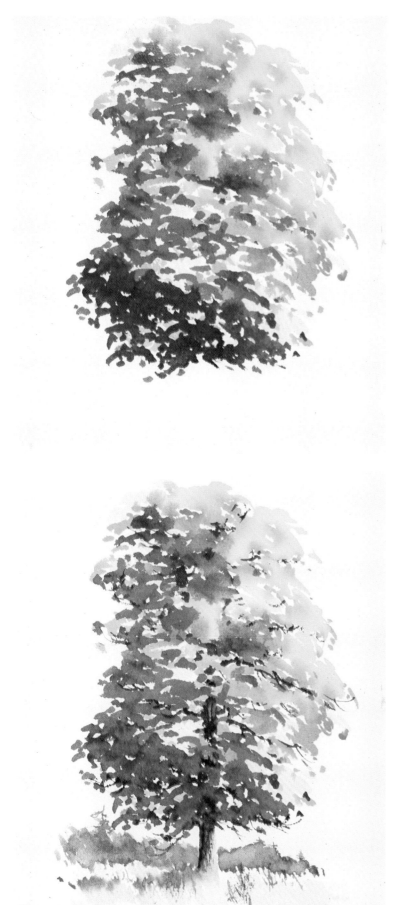

Step 3. The third value (in the case of a green tree, this can be made with a mixture of ultramarine and vermilion with viridian added) is painted on the dry surface and, like the second value, is blended in with spots of the earlier washes.

Step 4. The trunk is added and textured with a brush handle. The branches are tucked into openings left for them, and some of the surroundings are added. It's best if this can be done while the tree is still somewhat damp.

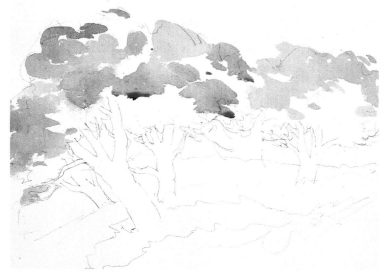

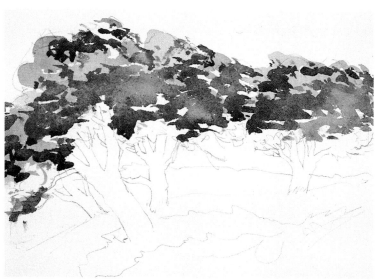

A Group of Trees

If you are doing a group of trees, follow the same procedure outlined on the previous two pages by painting *all* light areas first as a pattern, then middle and darker areas. While doing this, even though you work on a dry surface, use a loaded brush so you'll have wet areas of color and ample time to create flowing passages before the wash dries.

When painting trees (unless you wish to go into great detail), use simple areas of wash and plenty of blending of values; then put in a few detailed leaves on the fringes of the trees, and a few random ones at the edges of light areas. These leaves will identify the entire tree. Study carefully the shape and limb pattern of each variety of tree, so it can be suggested by brushstrokes—telling as much as you possibly can in the initial work. Studying and painting bare trees in fall and winter will help familiarize you with tree shapes.

Step 1. This is a group of oak trees on a California hilltop. The overall shape of the treetops is sketched, together with a careful drawing to suggest the character of the tree trunks. The lightest greens are painted first.

Step 2. The mid-value greens are added in the second step. At this stage you begin to model the trees, giving them the appearance of depth.

Step 3. In this final step, the third value of foliage is added, pulling the tree shapes all together. The trunks receive texture in an initial wash, then further detail when dry. Branches and twigs are added to give character to the trees.

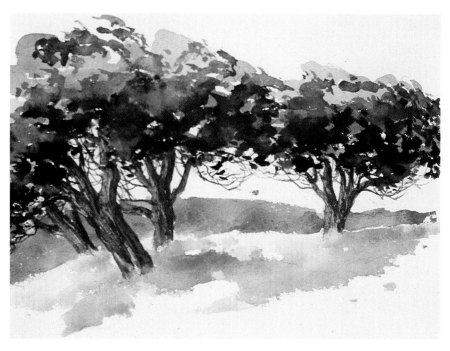

Basic Watercolor Techniques

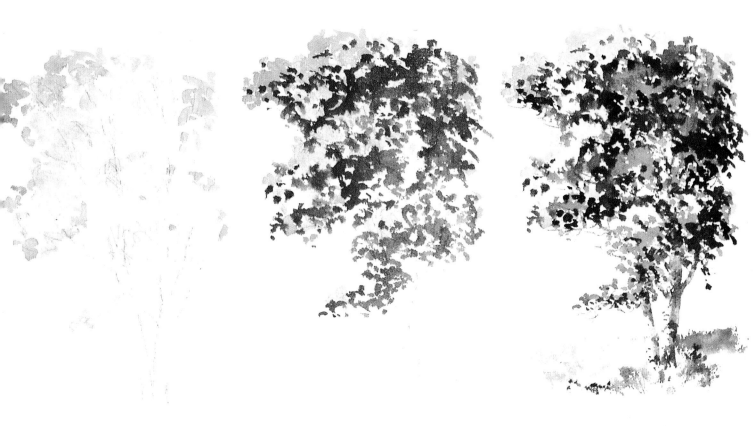

Birches

Step 1. When painting birch trees, pencil large shapes in slightly, then paint light areas of foliage very wet, leaving all other foliage areas dry.

Step 2. Add the second value to the foliage in the same manner.

Step 3. Finally, complete the darkest area of foliage, and add the shadow side to the trunk and branches. This trunk shadow can be a gray wash, blued somewhat with a little cerulean, but as you go higher into the tree and onto limb extremities, add a little cadmium orange and a bit of vermilion to create a warmer shadow on the trunks, and even a rusty color on branch ends and smaller twigs. This is characteristic of birches.

Now add the dark markings to the birch trunk and limbs. Keep these darks scattered, with no regular repeat of size or position. Frequently, the darks will appear as a saddle in a crotch where a limb or a side branch begins. These darks remain where a limb once was as well. In planning the surroundings for a birch, use darker areas or different hues in some places to define the white edge of a light trunk or limb. In other places, allow lights to create a lost edge—as well as darks against the shadow side of the trunk. This gives a freedom and looseness that causes the tree to be part of the landscape. In the late winter and early spring as buds form, these limbs and twigs become almost alizarin in color. When painting a birch tree without leaves, the shape should be done in a wet sky with a light gray wash dominated with alizarin.

Willows

Step 1. This painting began with a little watercolor sketch of a winter swamp with a cluster of old, battered willow trees. In the first step the sky, distant woods, and brush clumps were washed in.

 Step 2. While still damp, a darker wash was dropped into the sky where the shape of tree limbs, branches, and twigs was to be. A little more was added for a tree clump or two in the distance. While these additions were still damp, some brush-handle work gave limb texture to the wash.

 Step 3. In the next step, tree trunks and branches were painted in, feathering out into this wash. Finally, a few foreground accents and weed stalks suggest atmosphere. This is a very good way to create winter trees.

 A second method is to paint in the trees and then soften the limb ends while they are damp. If necessary, add a little wash for the tree form. This allows a little more control, but may not have the freshness of the method demonstrated here.

Trunks

Step 1. This demonstration shows how bark texture can be created with wash and brush-handle work. Note the trace of brush-handle work in the initial wash.

 Step 2. A second, darker wash carries similar texture. (Remember, when your second wash is applied to a wet wash it creates a darker line, but when applied as the wash begins to dry, lighter marks appear.) A few darker brushstrokes applied while the paper is still slightly damp finish the texture of this maple trunk.

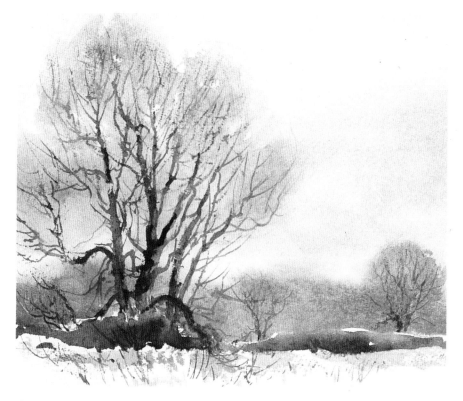

The trunk texture really adds to this tree
stump. Masking kept the flowers
untouched until the stump was
completed, and some masking was used
for distant flowers as well. A loose
background and sky were washed in.

The Ancient Stump
11 1/2"x 15 5/8"
Phil Austin
Collection of Mr. and Mrs. John Rosberg

Cedar Trees

Step 1. When painting cedars, begin with the light side of the trees, using a warm wash of cadmium orange and viridian. Next, mix a darker value, using more viridian and some ultramarine with the orange, and apply it while the first wash is still damp so plenty of blending occurs.

Step 2. Next, mix a dark value with vermilion and ultramarine, adding viridian until the dark becomes a proper green. This is added while the second wash is still somewhat damp. Keep this darkest dark in the center of the trees, so that even when it blends with the lighter wash there is a cylindrical feeling to the tree forms.

Step 3. Lastly, if more softness is needed, use the spray bottle for a burst of fine mist over the trees, allowing the outer edges to blur slightly. (Practice this on a few sample trees before you try it on a painting—don't wash away a good area.)

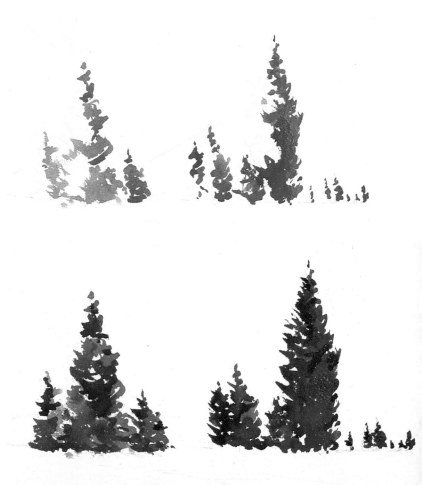

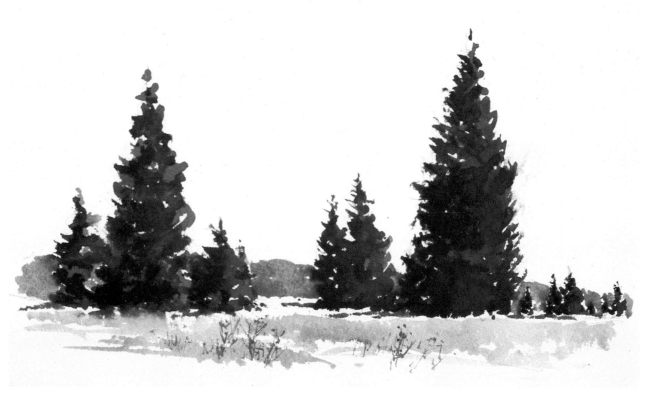

Basic Watercolor Techniques

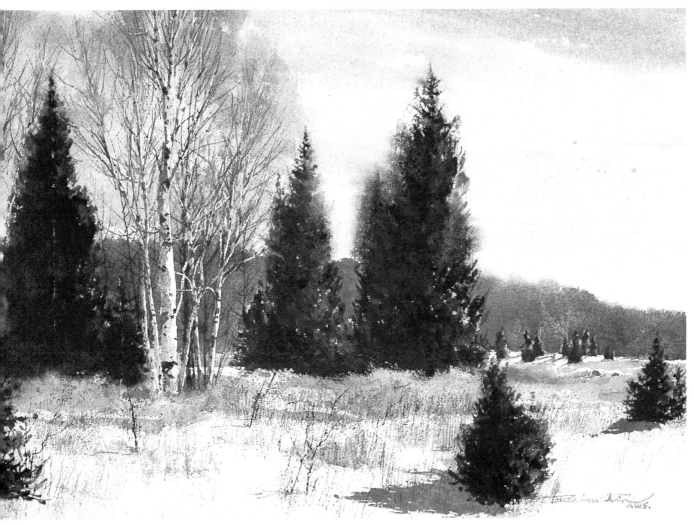

Pine Trees

Pine trees have individual character, as you can see in the illustration at right. It is always a challenge to find the best approach. The pine on the far right was painted with an effort to keep control, so the limb areas were moistened with clear water. After the glisten was gone, the light areas were washed in; then a darker value was added while the first wash was still damp, so the colors would blend. When dry, details were added with a small brush.

The two trees near right were painted rapidly, again following the procedure of light color first, then darker values. Immediately after laying in these washes, the trees were sprayed with mist so the edges blurred. (If working in the studio, you can use a 1200-watt high-speed hairdryer to arrest any spreading that seems to be going out of control.) Once dry, trunk, limb, and branch detail were added with a small brush. This second method is a good one. It takes practice, however, to avoid getting too much moisture on the trees and losing their character.

This painting makes use of the techniques for painting cedars and birches to capture the mood of the day.

The Quiet Time 14" x 21¹/₂" Phil Austin

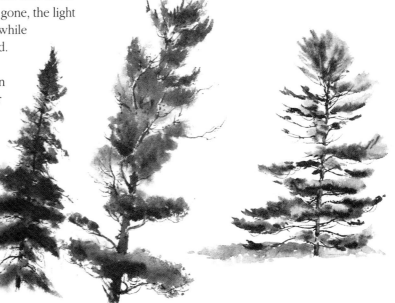

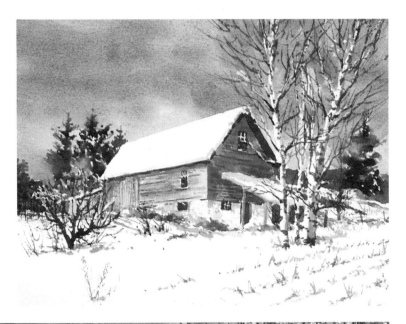

Snow

Landscape artists find snow scenes particularly intriguing. Capturing the illusion of snowy whiteness as it reflects winter light is a challenge few artists can pass up.

Step 1. First, a snow scene was painted in a strong value to allow for the brightening that would occur when the snowflakes were put in. Liquid mask was used to hold the whites of the birches.

The largest area, the dark stormy sky, was laid in, and the shapes of the birch trees were added into the damp sky with a mixture of alizarin, vermilion, and a little ultramarine. Then, brush-handle work was used to suggest many of the limbs. The evergreen skyline was added while some dampness remained in the skywash. When this was completely dry, the masking was removed. Small detail and some additional values in the snow emphasized the large, simple whites. Next, all the detail was added in the trees, building, and foreground.

Step 2. A discarded Dexter no. 3 mat blade, with its long point, was used to pick out the snowflakes. It may be tedious, but it makes the snowfall convincing. The snowflakes can be varied in size with complete control, to give the painting depth. This control allows you to present any type of snowfall—flurries, occasional flakes, or a heavy snowfall.

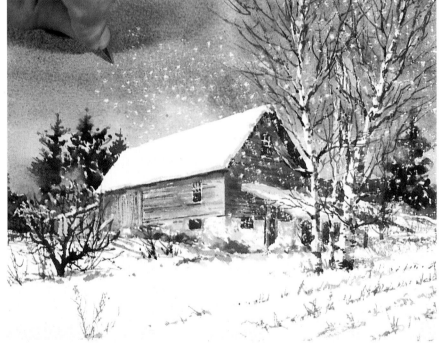

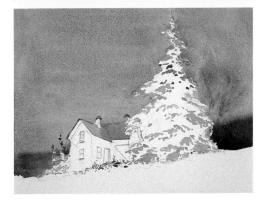

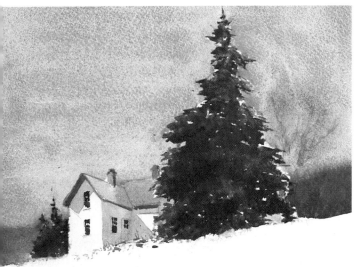

Evergreens in Winter

Step 1. When you paint winter evergreens with snow on them, put liquid mask on the snow areas first, so you can paint the trees freely and still hold the snow areas. The first step shows masking on the limbs (and on the ground area and white areas on the little building). The sky was painted, staying clear of most of the tree area.

Step 2. The second step shows the evergreen painted in and misted with spray to soften it.

Step 3. In the third step, the liquid mask was removed and a second value added for shadows and the weed stalks across the white areas in the foreground. Unless this is done, the white masked areas will look artificial—like cutouts.

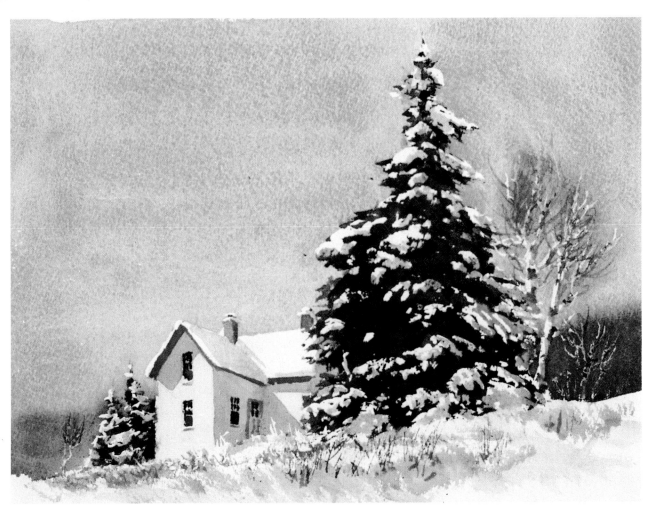

Snow and Light

The effects of light on snow are the subject of this demonstration. Here, the cold blue shadows themselves are the focus of the finished painting, not the surrounding view.

Step 1. In order to capture the prismatic effect of the light on snow, use John Pike's old trick: first, wet the entire sheet and flood in pale washes of the three primaries, letting them mix as they will. When the paper just begins to lose its shine, add the soft shadows of distant trees with a mix of cobalt blue and ultramarine. A judicious

use of salt in the damp wash adds that icy sparkle. (Some places were protected with liquid mask.)

Don't worry about where the cool shadows go on the upright tree trunk. It can be covered with a darker wash when the time comes.

The background is painted in quickly, wet-in-wet; then light trunks are scraped out of the damp wash with the handle of a flat aquarelle brush. (The

corner of a credit card will do as well.) If the scraping is done before the wash loses its shine, the paper's fibers will be bruised, causing them to absorb more pigment. This would create dark trunks in the distance, which could be effective, too.

Step 2. Add the dark of the upright trunk and the fallen, craggy stump. The stump's interesting shape should capture the viewer's attention, so reserve warmer hues and wider value contrasts for this area. Mossy greens are flooded into the wet wash with sap green and Hooker's green deep.

Step 3. Next, add the pale blue shadows on the snow on the stump; soften the edges by touching them with

Step One

Step Two

Basic Watercolor Techniques

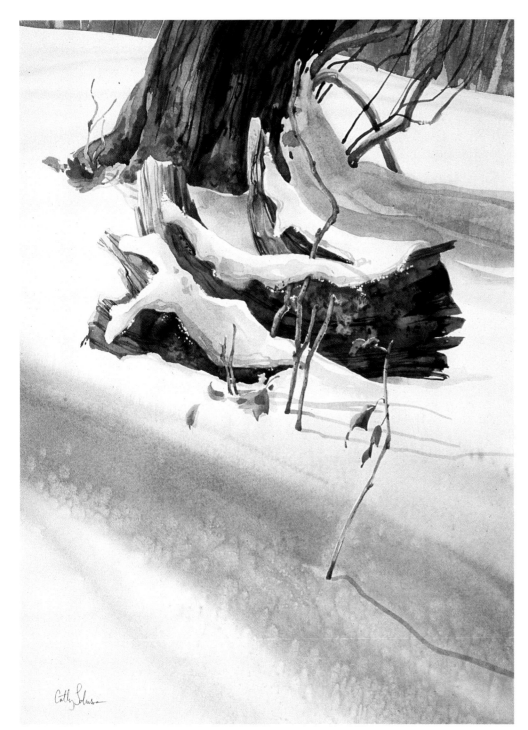

Cathy Johnson

Detail. *You can see the effects of scraping lights into the edges of the snowcap here, and the color variation in the twigs pushing up through the snow. Use color to express life. Uniform dark brown twigs would have been boring, a sign that the artist was taking the easy way out.*

Winter's Light
15" x 22"
Cathy Johnson
Collection of the Artist

a brush dampened in clean water. Pay particular attention to the stump's underlying roundness, and from what direction the light shines on it.

When this dries thoroughly, remove the liquid mask and paint the small twigs with their stubbornly clinging leaves of brown madder alizarin. Vary the colors for interest, and to impart a sense of life to the twigs. Their shadows are sharp-edged because they are close to their source—even in an already shadowed area, as in the soft blue foreground shadow, enough light will be present to make a darker, sharper shadow on close objects. Scraping will complete these small details on the edges of the stump's snowcap.

Perhaps you noticed the background tree's shape was changed in the finished painting. The artist felt its blunt entry into the ground lacked rhythm, so the large root to the left and a few fallen leaves were added.

Chapter Six
PLANTS AND FLOWERS
A Close-Up View

Plants and flowers are favorite subjects to paint; perhaps it's because they'll stand still. While birds and other wildlife make great subjects, unless you are quite good at stalking, it is difficult to get close enough to *see* the details, let alone have time to paint them. Flowers, plants, and trees, on the other hand, are easy to get close to, and as long as you catch them in season you will have days or weeks in which to work.

The painting at right was done outside the studio, in the woods. First,

the bloodroot flower and leaf shapes were carefully drawn to capture the wraparound effect. Other flower and leaf forms were delineated at the same time. First, the main flower forms were painted using fairly direct and mostly semidry washes. Some puddling was allowed in the large leaf form to suggest shadow and volume. Grass blades were painted calligraphically, using a single brushstroke to suggest their graceful forms.

The fallen limb in the background was painted with an oriental stroke,

allowing the side of the brush to skip over the paper on the left for texture. Mossy greens were flooded into this area while still damp.

A rich green-brown, made up of burnt umber and Hooker's green deep, was carefully painted in around the flower shapes and tiny stems, using a fine-pointed kolinsky sable, which was also used to add the final details to the flowers. The artist liked the unfinished negative spaces and decided to leave them alone.

Bloodroot and Spring Beauties
5" x 7"
Cathy Johnson

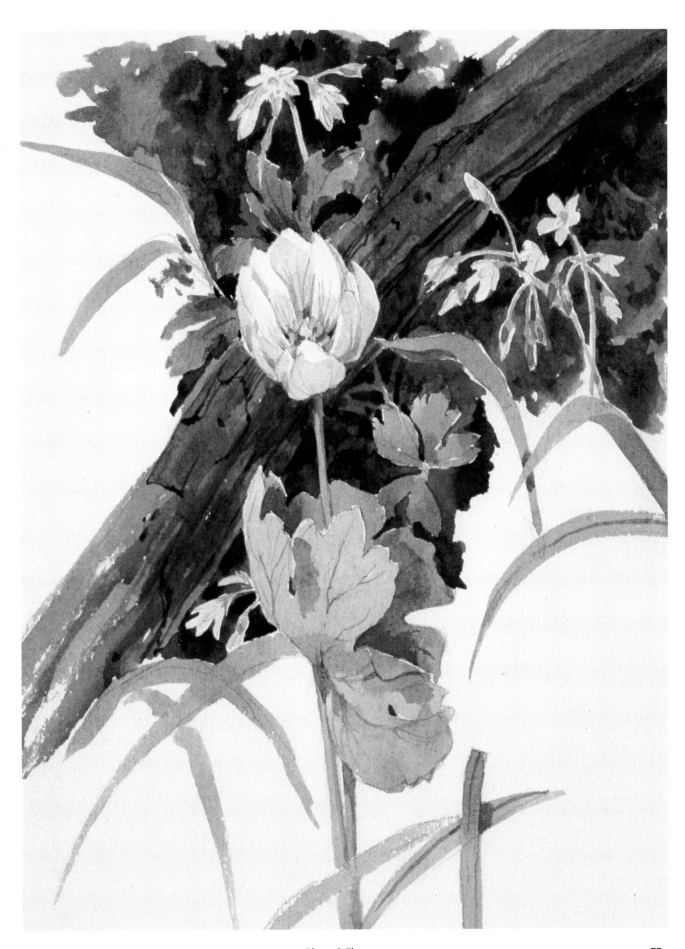

Seeing

Look beyond the normal, the everyday, or the expected for your painting subjects. Notice the negative shapes, the rhythms, the reflected lights. Close in on your nature subject for a new, almost Georgia O'Keeffe style. Consider the portrait approach, or the botanical style with its clean white background for emphasis. Look for varied shapes to add interest; painting details, such as flowers and plants, gives you this luxury, which would be just so much overworking in a larger landscape. Study plants closely in your field sketches; if you want, you can add one to a later painting for emphasis. (If you do this, though, try to make sure the plant or other added details are at home where you put them. Don't add cattails to a desert scene, no matter how much you admire them.)

Look for geometric forms and interesting juxtapositions when planning your paintings. Sometimes it's difficult to believe what we are seeing, and we may need a "key" to help us get the shapes right. If it helps, think of overall flower shapes enclosed in geometric forms. The drawing, top right, reprinted from *The Artist's Magazine*, shows an example of this. **A** Some flowers are a simple circle (daisies, wild asters, sunflowers), **B** some a cone (lily family members), **C** others a dome (peonies, zinnias, dandelions), and **D** still others might fit in a triangular shape. Try making rough sketches that would bound the outer perimeters of your flower shape, and then draw the actual flower inside. This will help keep the shape from getting away from you and becoming too large or distorted. (This trick can also be used when painting

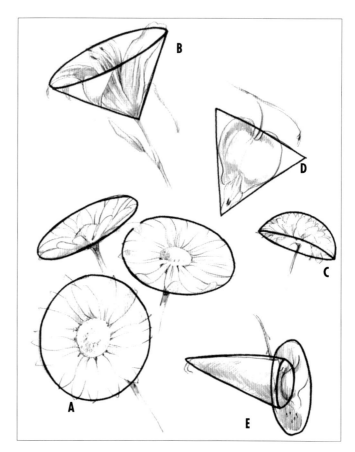

It often helps to think of flower shapes as simple geometric forms.

tree shapes to keep them in control.) If more complex flower forms are involved, break them down into separate parts. **E** For example, you may find that part of a flower, like a daffodil, may fit a circular or oval shape, while the rest would be represented by a cone or tube.

Notice that the top sketch on the facing page includes as much color as possible to define individual petals. In nature, white is seldom a stark, flat white. Flower petals, snow, and even buildings are affected by lights and shadows, time of day, overall lighting, and reflections of nearby colors. Look for ways to emphasize these reflected colors; play them up. A livelier painting results. Never use black as a shadow in nature; it's simply too flat and dead. Make rich darks by mixing complementary colors (i.e., red and green, purple and yellow) or the subtle neutral earth colors with blues (for instance, burnt umber with ultramarine blue or burnt sienna with cobalt). If

you are painting a subject with local color, as opposed to a simple white, you can use these darks or grays mixed with a bit of the local color in shadow areas. It even works with flowers.

Paintings of plants and flowers can look sickeningly sweet if you aren't careful. Keep your colors clean and vibrant, subtle, or rich and full to avoid a pastel sweetness that reads as simply weak. And if the subject *is* pastel, look for ways to present it in its natural habitat, with weeds, twigs, warts and all.

As was the case with *Bloodroot and Spring Beauties*, on page 77, *Sweet Williams*, on page 80, was begun by first painting in the small flower forms before proceeding with the background or the large dead stump. A wet-in-wet wash was laid in the background area. Texture was added with some spattering before moving on to the dark shape of the stump. Dry-brush and blotting techniques were used to give

the stump its rugged look, and then small details were added with a fine brush.

Using Your Sketchbook

Root patterns, stumps, bark, vines, thorns, twigs, plus odd shapes and directions are trees on a smaller, more comfortable scale. And weeds are simply wild plants we often overlook. But all of these plants are fascinating subjects to draw and paint.

Your sketchbook is a handy place to jot down ideas while you're in the woods—or anywhere you find an interesting tree shape. Note the differences in species; though they both have loose bark, a shagbark hickory's peeling bark looks very different from a fir's. An oak tree has gnarled, twisting branches; a willow, more graceful curves.

When you are painting nature's details, the challenge of foliage is, admittedly, somewhat different from painting a normal landscape situation. In a broad vista, where a bit of scumbling, spongework, or wet in wet reads as foliage, an intimate landscape calls for closer observation. Flashy tricks may not be as useful in these situations. Observation, then, is the key. *See* what you are looking at.

Keep your sketchbook with you at all times; you never know when you'll spot an interesting flower or plant. A quick sketch will not only capture a likely painting subject, but careful observation and drawing will help you identify plants from a field guide. Written notes may also help with this. Even if you're not interested in learning the names and habitats of wildflowers or plants, you may want to

*It isn't necessary to use precise shape—a rough approximation is usually sufficient to keep your shape in bounds; and it acts as a kind of framework and gesture sketch all at once. In this sketch, **A** a fairly regular circle becomes **B** a looser flower shape and then **C** blooms out into a natural form.*

In this sketch, the scene was simplified to focus attention on the stumps rising from the swampy backwater. If this becomes a painting, the white areas will be kept; it's not necessary to paint everything you see. As the artist, you are an editor of sorts; delete or add as needed to make a good painting.

The dark, rotting stump in Sweet Williams *provided just the background needed to make the flowers stand out, but the stump, sprouts, and twigs save this small painting from being too "sweet."*

Sweet Williams
9" x 12"
Cathy Johnson

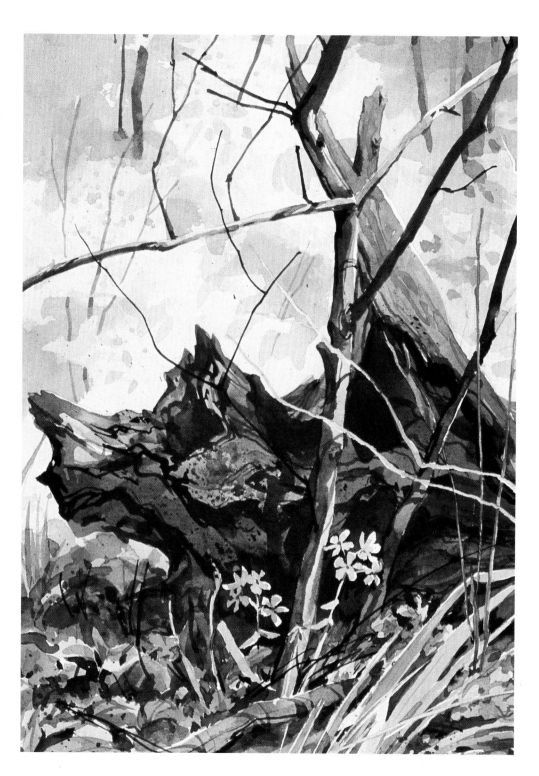

Basic Watercolor Techniques

title the finished painting with the correct name. It's embarrassing to mislabel a painting. (It's been done!) Field sketching, especially of wildflowers, herbs, and other plants, can become as involving and pleasurable an activity as painting itself. The dormant naturalist in you will come to life by observation and drawing. The sheer pleasure of learning, with no other end in mind, is half the fun.

Many of your field sketches may find their way into later paintings and illustrations. *The Local Wilderness,* published by Prentice-Hall, is almost entirely illustrated with field sketches or more detailed drawings based on field observation by artist Cathy Johnson.

Record all those small details to help your work ring more true as you paint nature's small treasures.

Various fungi (as well as lichens and mosses) make different and challenging painting subjects. Sketch these forms as you find them; you won't believe the fantastic variety. This small watercolor sketch is of a shelf fungus. Other forms are the more familiar toadstool shape and the sought-after Morchella esculenta, or sponge mushroom. Exercise your drawing ability on these nonflowering plants, and then explore them in watercolor.

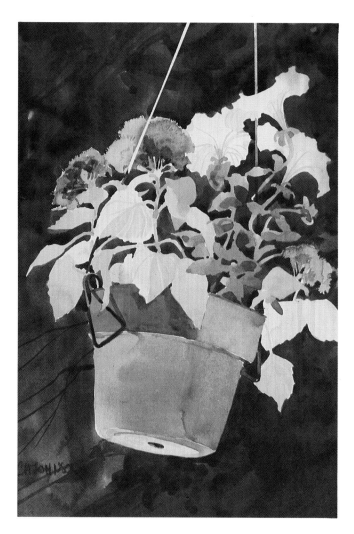

Petunias and
Friends
11" x 14"
Cathy Johnson

Even a potted plant can make a good painting subject. No liquid mask at all was used to paint *Petunias and Friends*, at left, but thin strips of masking tape were used to protect the plant hangers. A deep wash of Hooker's green dark, burnt umber, and ultramarine blue was painted around all of the flower and leaf forms.

The rich burnt sienna of the clay pot, mixed with a bit of ultramarine to add a sedimentary texture in the shadows, makes a warm contrast to the cool colors of the leaves and flowers.

In this painting and in *Backyard Violets*, page 89, the strong contrasts of light and dark helped describe the quality of light. The sunlight cast deep shadows, making the flowers seem to pop out of their setting. This effect was accentuated with a wide value range as the painting progressed. Look for strong contrasts in nature, and find ways to put them to work.

Iris in Sun, at right, is a botanical painting, with the subject vignetted against a white ground and bounded with a loose border—hardly an object found in nature! This was painted on the spot as an exercise in brush handling. Each of the petals, buds, and leaves was done as a single stroke, at least in the base washes; manipulation of the brush accounts for the varied shapes. The artist used a large no. 12 round brush, in a somewhat oriental technique. Try holding your brush vertical to the paper and vary the pressure on the hairs to change line width. Let each stroke stand as you put it down to retain freshness; some puddling will occur, giving a sense of dimension to the forms.

Some colors can be allowed to flow into others for unity. In the bud areas,

Basic Watercolor Techniques

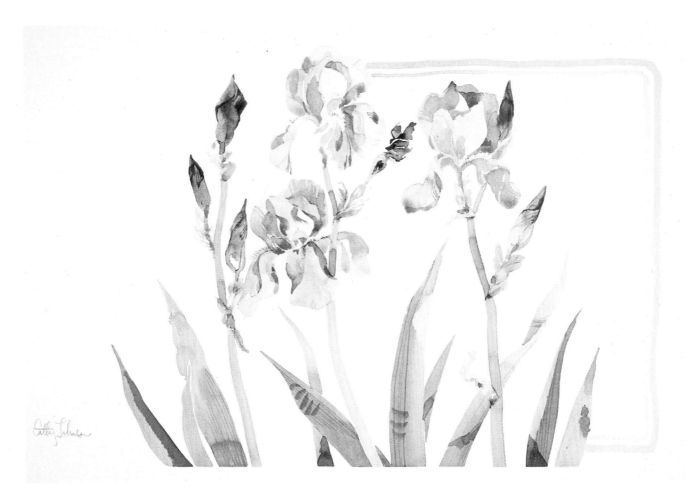

the brush was charged with a soft green or lavender green, then the tip was touched into a strong mixture of alizarin crimson and ultramarine blue. The purple tip touched the paper first, then the body of the bristles was brought in contact with the paper. Learn to use your entire brush rather than just the tip—otherwise, you'll be tempted to draw with your brush instead of paint. (If you're using a calligraphic style, of course, that approach is fine; otherwise, use the whole brush.)

Iris in Sun
15" x 22"
Cathy Johnson
Collection of Susan Bollinger

The Portrait Approach

A found composition, with changes only for aesthetic reasons, forms a "nature portrait." These include the background and other plants and natural objects, as well as the subject itself. You can use a still-life approach, if you prefer more control over your subject and its arrangement. But when painting a portrait of a flower, try to paint it in "comfortable" surroundings, just as you would a human subject.

Step 1. Step 1 shows the preliminary drawing, with the columbine, its stems, and leaves protected with liquid mask.

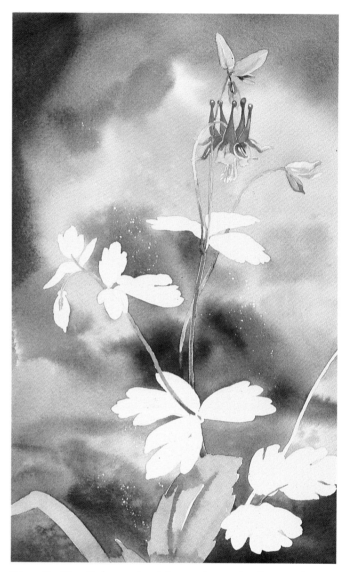

Step 2. Step 2 shows the rich, wet-in-wet background wash of greens and a deep purplish shadow of brown madder alizarin and ultramarine blue. Some of the forms are beginning to take shape. A soft, out-of-focus background, almost photographic in effect, helps create a sense of depth, and also focuses attention on the foreground flowers and leaves. Notice small details like the redness of the stems; all stems aren't green. Next, color was added to the flower itself, carefully shaping it.

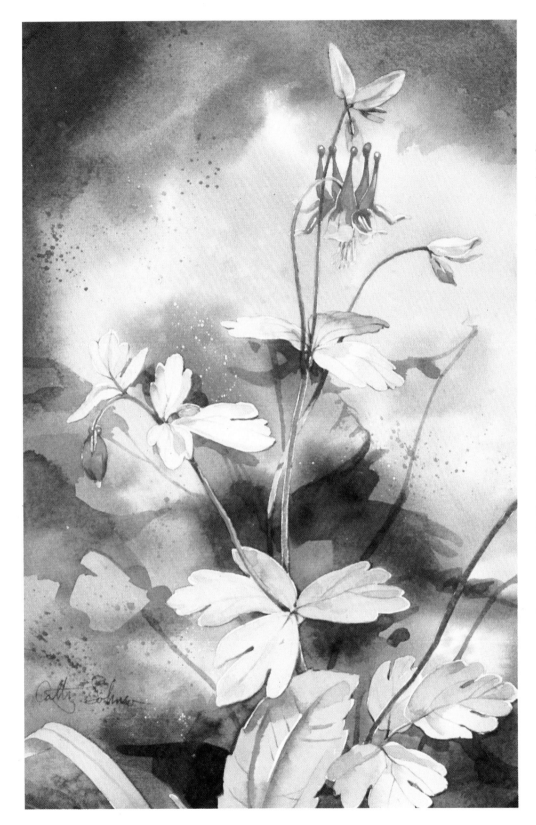

Step 3. In step 3, a lot has happened. The upper background didn't provide enough contrast, so it was wet with clear water and another, darker shadow wash was applied using a light touch to avoid lifting the washes underneath. Then, the leaves and stems were painted and modeled, and the bud on the left was added.

Somehow the picture was too flat, so additional background shapes were suggested to make the leaves come forward and give a sense of the various levels and planes. A little spatter added texture and interest without overworking. (Spatter is great for this!)

Wild Columbine
11" x 14"
Cathy Johnson

Sketch

The Botanical Approach

Attention to correct botanical forms, plus the removal of distracting background details—and sometimes the inclusion of notes on size, shape, season, Latin names, and uses—makes a botanical painting. Seed cases, seeds, and roots may be shown. Botanicals have a fresh but timeless feel; some of our earliest flower paintings were done in the botanical style.

Sketch. In order to capture the illusion of depth on the flat paper plane, consider that flowers obey the laws of perspective like everything in nature. Look at the schematic drawing of the composition; the tulip is tipped forward, inviting the viewer into the illusory (if intimate) distance implied. The individual flowers on the narcissus stems are on different planes and at varying distances from the eye, as well. Dotted lines in various circles, ovals, and discs demonstrate the variety of direction; if we ignore such things, our paintings will look as flat as folk art.

Final Painting. To maintain the flowers' clean, fresh feel, the painting was done as directly as possible. The tulip's colors are mainly tints and shades of cadmium red medium; there is only a small amount of shadowing done in its depths to give a sense of dimension. Shape and direction are the main sources of this illusion.

The narcissus was painted more carefully, one flower at a time in successive washes, to retain their freshness and identity. Notice that reflected lights, in this case yellows, blues, greens, and even some pinks, give a sense of life and interest.

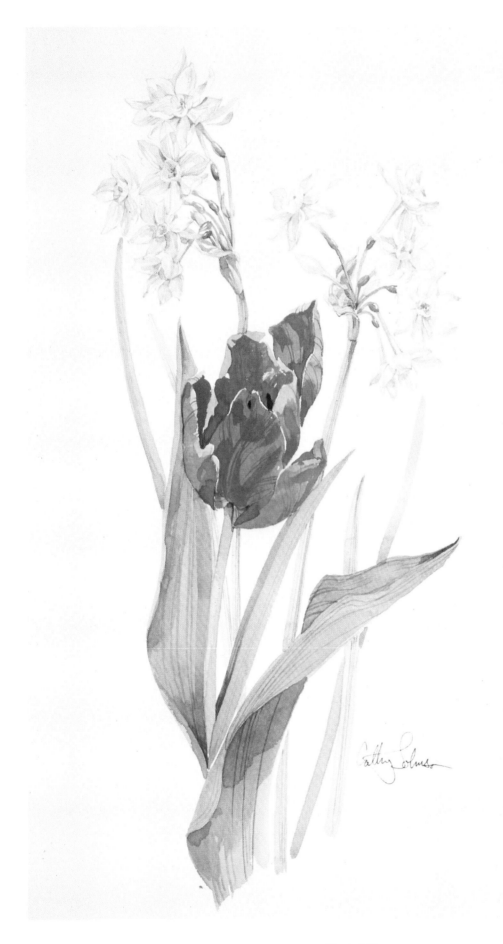

Can Spring Be Far...
10" x 14"
Cathy Johnson
Reprinted courtesy of
The Artist's Magazine
Collection of Betty Bissell

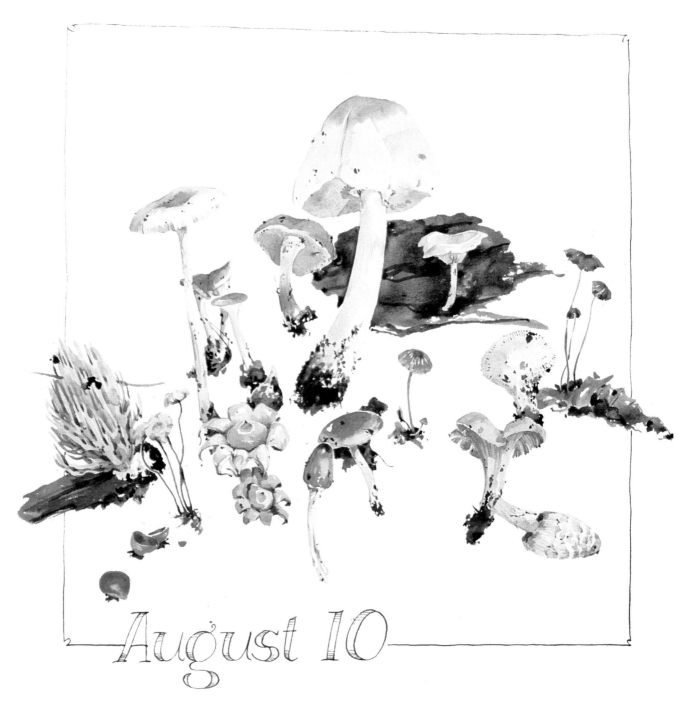

August 10

These mushrooms were done with a rather botanical handling; notice the careful attention to the details of the fungal forms against a white background. In some areas, washes were built up slowly in glazes; wet on wet was used when possible for freshness. The bright red allows the scarlet cup mushrooms, lower left, to come forward from the picture plane.

Composition or placement in this type of painting becomes especially important, because there is nothing else to lead the eye into the picture plane. Before beginning, an overall rough form was planned. The largest mushroom was placed just off center, and the brightly colored forms were allowed to make accents into secondary triangles. Repeating a geometric form within a composition imposes a sort of order on an otherwise scattered array of separate objects. Look at this painting closely—see if you can find all the triangles within the overall shape. The relative sizes here are correct, and nearly everything is life-sized.

August 10
16" x 20"
Cathy Johnson

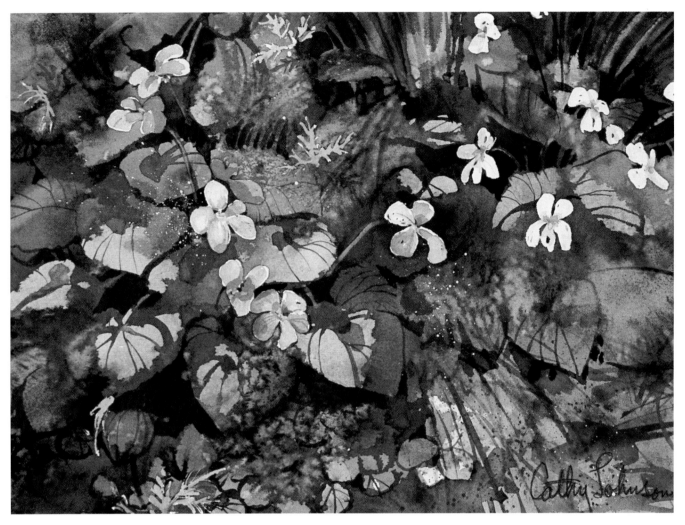

To capture the exuberant growth of these violets, the artist used a wet-in-wet technique, using liquid mask to protect only the flowers themselves and a few fernlike leaves. A light spatter of liquid mask was added, too. Then, the entire sheet was wet and a rich mixture of sap green and Hooker's green dark was washed in, with a bit of sienna and burnt umber in the lower right. The paper was kept quite wet during this stage. Salt, spatter, and a little scraping-out in the upper right areas suggest the beginnings of foliage forms. The artist continued to work in this area while the wash dried, delineating the heart-shaped violet leaves. When this was well-dried, the liquid mask was removed, and the white and lavender-colored flowers were painted in with a small no. 4 brush. The spattered liquid mask, when removed, suggests pollen in the air.

Backyard Violets
11" x 14"
Cathy Johnson
Collection of Mr. and Mrs. Claude Adam

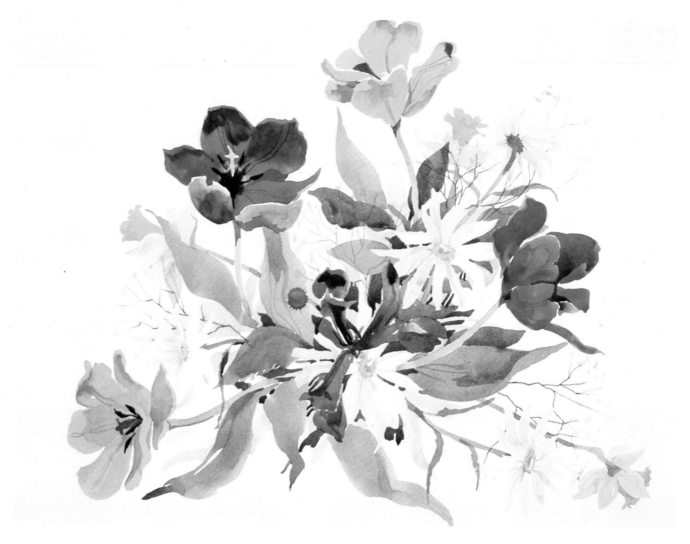

Bouquet
15" x 22"
Cathy Johnson
Collection of Mr.
and Mrs. Keith
Hammer

Exuberant spring colors, after a long winter of subtle colors, inspired this botanical painting, *Bouquet*. These are dye colors, very strong when used directly from the bottle. Although usually somewhat diluted with water to improve their washing ability, they are often useful to paint the bright, strong colors of flowers. Be careful to choose permanent colors; some are quite fleeting.

Here a direct painting method was used, with only the barest of preliminary drawing as a framework. As in *Iris in Sun*, a calligraphic brush technique was used—each flower form was painted in one sure stroke. (As you can see, the artist's exuberance resulted in a scarlet splat right in the middle of the composition. She liked it! It stayed.) Dutch iris, red and yellow tulips, daisies, daffodils, and baby's breath (from the florist) make a nice composition, based on an overall triangle shape.

The Monumental Image

Imagine a plant so big, so commanding, that you almost become lost in its depths, surrounded by beauty, like some of Georgia O'Keeffe's monumental paintings of flower forms. Focusing closely on plants or flowers gives us a whole new perspective. Try this for yourself. Pick a single flower, or only a very few at most. Let the flower fill your picture plane. Get within inches of it; get to know the shapes, the delicate transparencies, the very cells that make up the petals. Explore the shapes of pistils and stamens; look at their shadow shapes. This approach can be a fresh and startling one.

Flowers you might handle successfully in a monumental way include peonies, roses, tulips, poppies, and daffodils. This kind of attention, painting details to create immense blossoms, helps us to appreciate the complexity of nature.

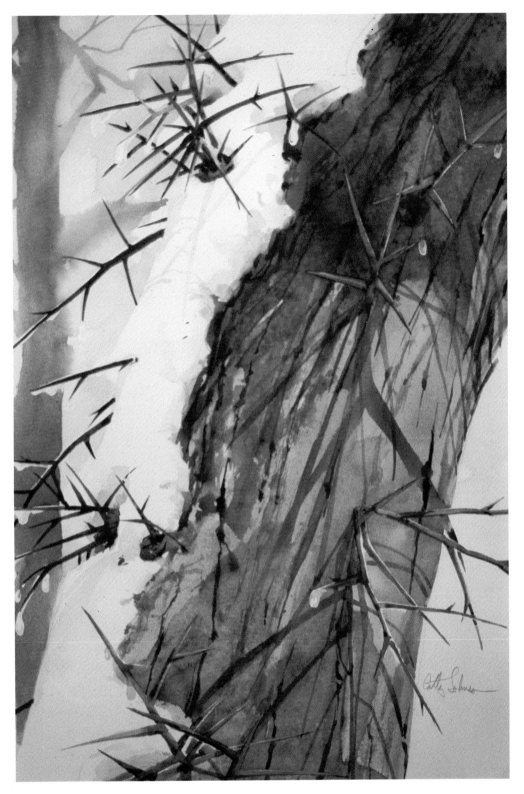

Honey Locust
11" x 14"
Cathy Johnson
Private Collection

Subtle colors work well to capture other seasons. You might want to experiment with such understated colors to paint a bouquet of winter weeds, fall flowers, or even some of the rich brown-colored orchids.

Winter's subtle colors are as much the subject as the ice-covered thorns and wet snow on this honey locust tree. The thorns are almost startlingly warm-hued next to the cold blues of the ice, snow, and wintry sky; adding to the contrast, the thorns cast long shadows and are tipped with dripping ice. The thorns' angular shapes were protected with masking tape, while the bark behind them was painted with burnt umber, ultramarine blue, and a little sap green to express the feeling of the algae and lichen that had formed on the damp surface. Shadow shapes were painted before removing the tape.

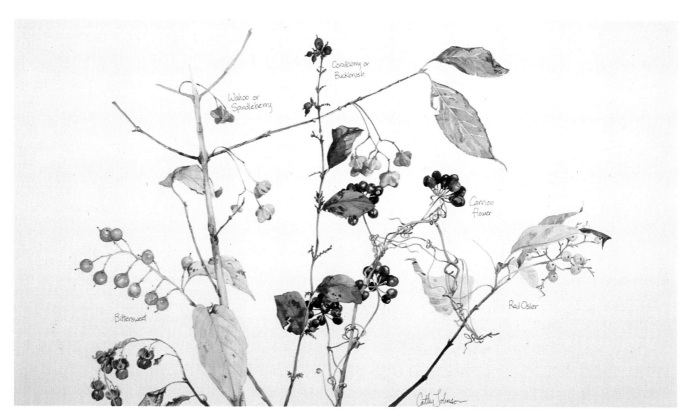

Labels within image: *Coralberry or Buckbrush*, *Wahoo or Spindleberry*, *Carrion Flower*, *Bittersweet*, *Red Osier*, *Cathy Johnson*

Fall Fruits
15" x 22"
Cathy Johnson

Fruits and berries make wonderful subjects as well; their variety of shapes, forms, and colors lets us create rhythms, studies, or botanical works—whatever we wish.

Sequential Images

Change and growth are integral parts of nature. From sprout to flower to fruit: plants and flowers lend themselves especially well to sequential studies. Get acquainted with a plant over a period of time and you will be fascinated by the visual changes that represent the endless cycle of natural life.

One trip to a twenty-foot-long section of country roadside provided the subject matter for *Fall Fruits*, shown above.

Leaf, berry, and stem shapes were

carefully drawn in an informal arrangement. They weave in and out of each other, tying the composition together with their overlapping forms.

The amazing range of colors found on this one small stretch of road had to be painted to be believed: bittersweet's red-orange fruits and lighter orange outer husks, spindleberry's (or wahoo's) pinks and reds, buckbrush's magenta, carrion flower's almost black fruits,' and red osier's pale berries with their reddish stems.

The slow buildup of controlled washes and glazes added form and color to the leaves and fruit.

Look for forms in nature to study closely; fruits, grasses, weeds, nuts, and other plant parts make interesting studies and are a welcome break from flowers.

Basic Watercolor Techniques

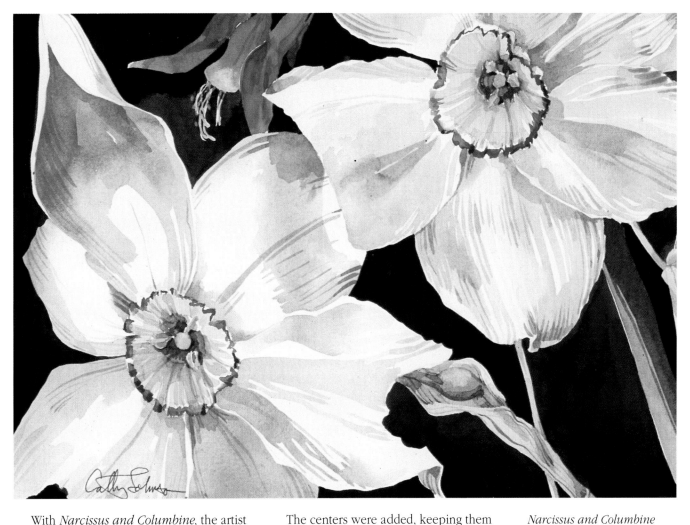

With *Narcissus and Columbine*, the artist took an extreme close-up approach to focus attention on the deceptive simplicity of the subject. Letting the flower shapes fall outside of the picture's borders enhances the feeling of intimacy; the black background further focuses interest.

The more complex form of the columbines is included as a kind of counterpoint to the repeated circles or ovals of the narcissus. The related color notes of the tiny red border of the narcissus's center and the columbine's convoluted petals put repetition to effective use.

Lightest colors were painted first, then the modeling and veining of the narcissus's outer petals. A combination of cobalt and ultramarine blues, burnt sienna, and cadmium red and yellow were used to express the light-filled shadows. Hard edges were softened with a thirsty brush (one rinsed in clear water and wiped almost dry).

The centers were added, keeping them rather free-form within their outer perimeters to give a fluted feel. Cadmium yellow light was the basic wash. Using greens and blues, the centers were darkened to give a sense of depth, and the edges were painted last with a strong cadmium red light. Here and there, where the yellow was still damp, colors were blended for softness.

The columbine was more difficult to paint believably. The artist separated the petals and did the outermost ones first, then painted the middle one alone to maintain better control of the blending of the yellows and reds. The colors of the pistils were exaggerated so they would stand out against the dark background, which was added last. The background is made up of a very strong mixture of Payne's gray, alizarin crimson, and thalo blue; black could have been used here, but this mixture maintains a hint of color.

Narcissus and Columbine
11" x 14"
Cathy Johnson

Subtle Contrasts

This fallen tree was a giant among the smaller upright trees and miniature wildflowers. The soft overcast day made it a painting challenge: all the elements were of similar value, making for very little contrast. In a way it was advantageous, because the sunlight and shadows filtering through the tree canopy would have made a confusing subject.

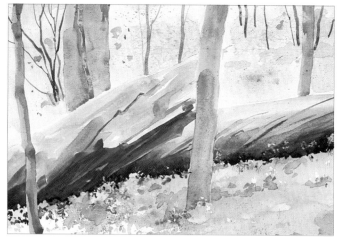

Sketch. A quick watercolor thumbnail sketch was made to be sure this was a painting subject. This solved several problems, giving some hints on how to handle the final painting. A lighter, simpler background with just a hint of detail would push this area back; cooler mixtures for the trees behind the fallen giant would keep them in their place, too. A warmer mixture on the closer trees would make them advance toward the viewer.

Step 1. In step 1, liquid mask protects the tiny wildflowers and leaves growing beside the huge fallen log. A mixture of thalo green, modified with cadmium yellow light, yellow ochre, and a touch of burnt sienna were washed in here and there to keep it from being too acid-green. A one-inch aquarelle was used for this. While the wash was still wet and making interesting puddles, a touch of salt and spatter of liquid mask were added right into the damp wash.

Step 2. When this was dry, the tree forms were painted in, keeping in mind the lessons learned from the sketch. The background trees are much cooler than those in front of the fallen and broken log. Gradated washes modeled the log itself. The picture started with a light wash on top, where it reflected the light of the sky, then proceeded to a very deep-shadowed wash where it nestled among the flowers. This provides contrast and gives a feeling of roundness. At this stage, the lines of the woodgrain were interestingly twisted around the old trunk like ribbons around a Maypole. To accentuate the wood's change in color where the huge tree had broken, the warmer-colored heartwood became the center of interest.

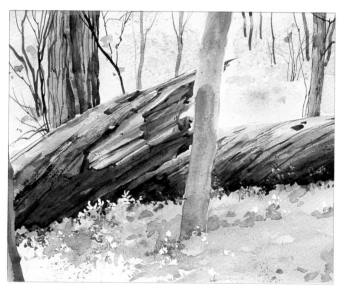

Step 3. The feeling of overlapping planes gives a sense of volume and distance. The right-hand section of the log is lighter, in keeping with its simple, cylindrical shape, while the log that rests on the slope of the hill is deeply shadowed underneath. You can see the difference between the two planes in this detail shot.

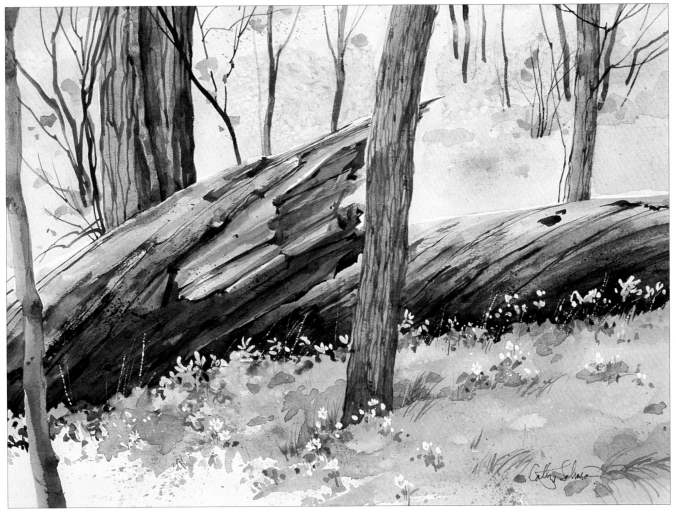

Step 4. In the final stage, the liquid mask was removed and final details were added to the tree bark and the log. Some moss and algae color had been laid in during the original washes so it would blend; in the final stage, dry-brush mossiness was added to accentuate texture. Dry-brush was also used to weather the log itself. The small leaves against the log were loosely painted, letting some remain white to look light-struck. When the paper was thoroughly dry, a few blades of green were scratched in with a sharp craft knife.

Wildflowers in Spring Landscape
15" x 22"
Cathy Johnson

Chapter Seven
WATER
Capturing the Most Elusive Subject

Endlessly moving or still and reflective; clear and sparkling with light or roughly tumbling over a miniature waterfall: water patterns on this intimate scale are fascinating painting subjects. For centuries artists such as Winslow Homer, John Marin, and Albert Bierstadt have captured the grandiose proportions of the sea, great rivers, and mist-shrouded waterfalls. When we take a closer look at nature, we find a whole new dimension to the subject on a smaller, more comfortable scale. Certainly Niagara Falls is impressive, but for most of us the smaller lakes and rivers—or even a nearby creek—are more accessible on a day-to-day basis than Niagara Falls or the pounding Atlantic shore.

Sand Point, at right, is a study of tiny wavelets lapping against a small sand peninsula left by the latest high tide. Even the half-submerged pebble disturbs the water's sensitive surface.

A careful pencil drawing of the subject was made directly onto the watercolor paper, paying close attention to the random pebbles and the nice shape of the sand point. Some of the weeds and pebbles were protected with liquid frisket. Once that was dry, the light water and sand were painted.

Notice that where the sky reflects on the water there's a certain opacity—the little rocks are barely visible under the surface, even though the water is no more than an inch deep. Their varied shapes have been indicated with the tip of the brush on the dried wash of pale thalo blue.

The water itself is mostly transparent; it looks brown because you can see right through to the mud and pebbles below. A rich mix of algal brown, raw and burnt umber, and a dash of Hooker's green deep was used to follow the pencil "map" of wave shapes, painting from the relatively simple upper right corner down to the loose waves around the shoreline and point. Some edges were softened with a brush loaded with clean water, then blotted quickly.

When that dried, the frisket was removed from the weeds and pebbles and they were painted in. Notice how the artist has painted the wonderfully diverse shapes and colors, trying to maintain a shiny, wet look.

Darkest accents came last—the wave patterns really became wet-looking as they got their secondary washes. The careful attention to the cause of these secondary patterns is what makes this little painting work.

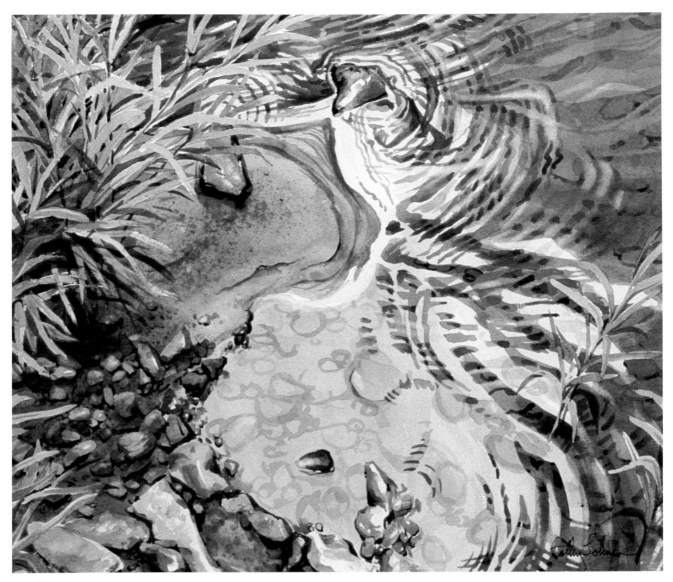

Sand Point
10" x 12"
Cathy Johnson

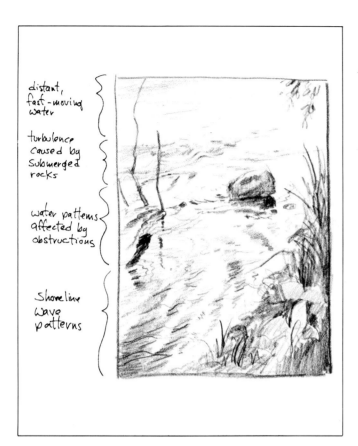

distant, fast-moving water

turbulence caused by submerged rocks

water patterns affected by obstructions

Shoreline wave patterns

Look for the logic behind water patterns; every effect has its cause.

Water Patterns

Water patterns vary from lake to river, even within the same body of water. A submerged rock causes interesting, undulating shapes, which affect reflections on the water's surface. The shape of waves lapping against the shore differ from those breaking around a protruding object. Still water *does* run deep (unless it's a quiet, protected pond or stagnant swamp!); here, the reflections will become your primary subject. When bubbling over shallow rocks or water-polished pebbles, the surface will be broken and sparkly. To know what makes each pattern, learn the logic behind the water's movement.

The sketch, above, shows some common water patterns and explains their causes. The distant, fast-moving water has little to mar its surface—you may see only a few indications of current. A few feet away, in shallower water, the surface is wrinkled and active. Long streamers of water flow downstream away from obstructions.

Even a small twig causes a change in this expressive surface; a rock displaces proportionately more water, making the patterns broader and deeper. As waves break against the shore, they resemble miniature ocean surf. Look for these patterns—to help you "see," make an annotated sketch like this one to explain what is really happening. Later on, such memory jogs will help you interpret your subject more believably.

Freezing Motion

Water patterns can be confusing at first—the continual motion makes water seem almost impossible to paint. If you watch over a short period of time, the patterns may change somewhat, but the object that causes them does not. The same pattern—or one similar to it—will appear again and again. Sketch it quickly, then work on your sketch each time your original pattern reappears. This is also a perfect place to make use of the sketching tool popular with artists for decades—

the camera. A relatively fast shutter speed freezes the action of the water, making it "a snap" to study at leisure. A slow speed will make a soft blur if water is moving rapidly—an interesting effect to attempt wet in wet if you're brave enough!

Turbulent Water

This is the most challenging water pattern to paint. Even if a waterfall is quite small—no more than a foot in height—there's still a *lot* going on. Painting such a scene without over-working is the challenge here, but again, a basic understanding of what *causes* the pattern is the answer. Simple observation is the key.

Still Water

In very still water, reflections may be perfect mirrors of their object (upside down, of course), but that isn't always the best way to paint them. A bit of variation in line and direction "says" water to the viewer's eye. Look to capture that watery effect without making a confusing statement; if your painting looks just as good upside down, your audience will feel disoriented.

Gradated washes help to give the feel of distant, still water; you will almost always be able to discern some slight movement in the water, either from an underground source or from the motion of the air. Wet-in-wet wave effects help break up a too-still body of water.

In creating *Waterfall*, far right, the background was painted first, wet-in-wet, with a rich mixture of thalo green, cadmium yellow, thalo blue, and a touch of brown madder alizarin at the base of the tufts of grass for a bit of warmth and contrast. While this wash was still damp, individual grass blades and weeds were scratched in.

The area where the water breaks over the rocky ledge is the center of interest and the area of greatest value contrast. The white paper acts as the water's shine.

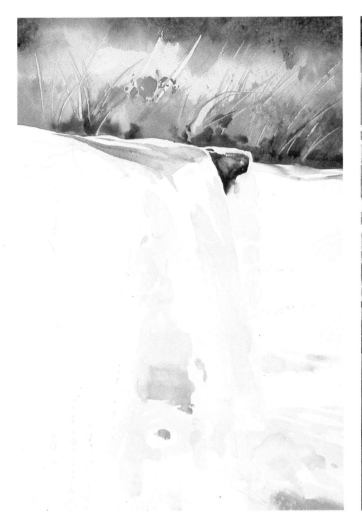

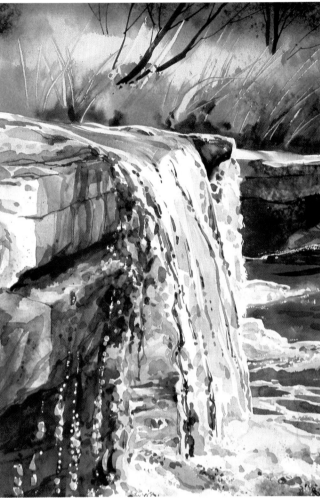

Waterfall
15" x 22"
Cathy Johnson

Even though this is moving water, it still reflects both the blue unseen sky and the green bordering forest. These color notes were introduced at the top of the falls with some intensity, using the thalo green, thalo blue, and a bit of Hooker's green deep. Down in the waterfall itself, where the water lightens when mixed with air, the same colors are used, but in a weaker concentration.

Attention was focused on details: What causes the shapes in the water? What is the source of color where the rocky ledge dips and recedes, then thrusts out like an assertive chin at the area of greatest contrast?

For the rock forms, warmer colors were used than were actually present in nature to help separate the rocks from the cool greens and blues of the water. Although nature is an excellent teacher,

in the interest of a good, readable painting you have license to change what you need to. If you wish to make a slavish copy of nature, you would do better with a camera. Ultramarine blue, sepia, and burnt umber were used in the shadowed areas. Rocks were spattered, scraped, and blotted while still damp to give them the rugged texture characteristic of Missouri limestone.

At the near edge of the falls the water moves slower—the stream breaks in two directions, though still knotted together at the top with droplets. Successive washes captured this effect.

Between the two streams you can see the roiled, muddy water—it's amazing how many colors and shades appear in one little waterfall! Liquid frisket protected the droplets on the lower left; they were tinted after it was removed.

Organizing Water Patterns

Here, the subjects are the moving water and low early morning light. Again, a strong abstract composition forms the backbone. The small thumbnail sketch helped organize the composition before work was begun on the clean sheet of watercolor paper.

Step 1. Once position and composition were decided on, the rocks were sketched directly onto the watercolor paper. A bit of liquid mask was spattered in the distance (a nice trick to give the effect of light on water or distant air bubbles floating on the surface). A few touches of liquid mask here and there maintained the lines of the current.

The entire surface was wet, using a water sprayer and a clean brush to avoid overwetting. Ultramarine blue, burnt sienna, and a bit of sap green were mixed to make the soft reflections of the far hills, and a blush of alizarin crimson was added in the left side of the painting to suggest the early morning glow.

Step 2. Next, the rocks were painted, getting as much color variation as possible without losing the sense of rockiness. The blue sky reflects in the upper surfaces—a bit of thalo blue was used to capture the effect. Ultramarine blue, raw and burnt sienna, and a bit of brown madder alizarin were used for the rocks' variable colors, and when the pigments lost their wet shine, they were sprayed with clear water for texture. Here and there the droplets were blotted to further texture the rocks (a bit of salt could have been used here, too).

Notice the warmer color in the closer rocks. Even though in intimate landscapes we often deal with distances of only a few inches instead of yards (or miles), it's still a good trick to remember that cool colors recede and warm ones advance. (With thought and foresight you can manage to break this rule quite happily if you like.) In this instance, the rule used stands, and the foreground rock is just a bit nearer to our eyes by being warmed with burnt sienna.

When the rocks were dry, their deep shadows were added with a rich mixture of ultramarine blue and sepia; then, using a flat watercolor brush, the water's far reflections were laid in with Hooker's green deep, sepia, and a bit of alizarin crimson.

Step 1

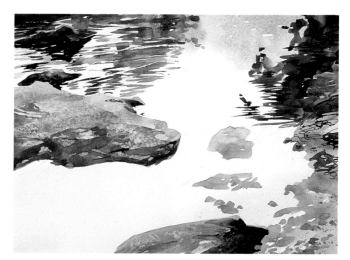

Step 2

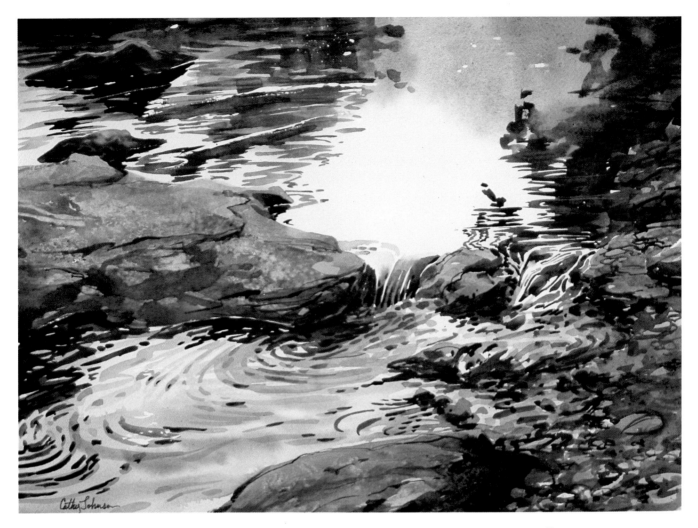

Step 3. Finally, the foreground water was rewet and the waves were worked wet-in-wet. When that was dry, the small riffle that fell a few inches over the rock ledge and the dark shapes in the rippled foreground were carefully modeled. A rich mixture of the same background reflection colors were applied with a round watercolor brush.

Since the *action* of falling water is really the center of interest, your eye is led to that point by values and direction, but the waterfall itself has to merit the attention.

Some edges were softened with clear water in the brush while they were still quite wet; these could also have been blotted while damp, or the edges softened with a bristle brush and water once they had dried, but you may want to experiment with getting fresh blending effects in the first attempt. Scrubbing and lifting sometimes leave a muddy residue.

When the water fully dried, more shape was added to the rocks and pebbles in the lower right with a no. 7 round brush, reserving some whites to maintain a look of wetness.

Riffle
15" x 22"
Cathy Johnson

Water in Motion

This on-the-spot study of rushing water, right, was done in early morning light. Without full studio paraphernalia, the artist relied on painting around and scraping out the whites. This sketch gives a good feel for the water's action.

Final Painting. In the large painting, far right, liquid frisket and salt were used to retain some of the whites and give a feeling of frothy water. The dam and the patterns in the water below, as well as the linear effect of the water as it fell, were roughly sketched in. The small whirlpool below was especially expressive.

Pigment was applied fairly traditionally here, light to dark. Some of the darks on the dam got too dark, so they were washed back with clear water and a bristle brush.

Some of the small twigs were scratched into the damp shadow wash, regaining their light shapes. The composition has strong abstract qualities.

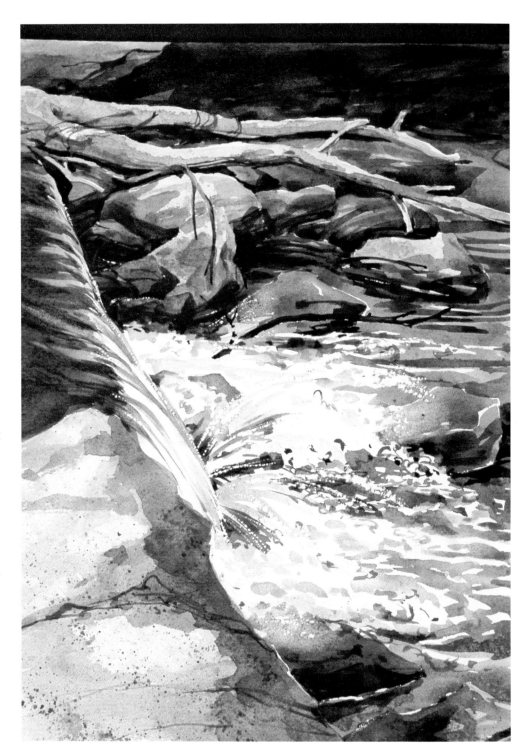

Basic Watercolor Techniques

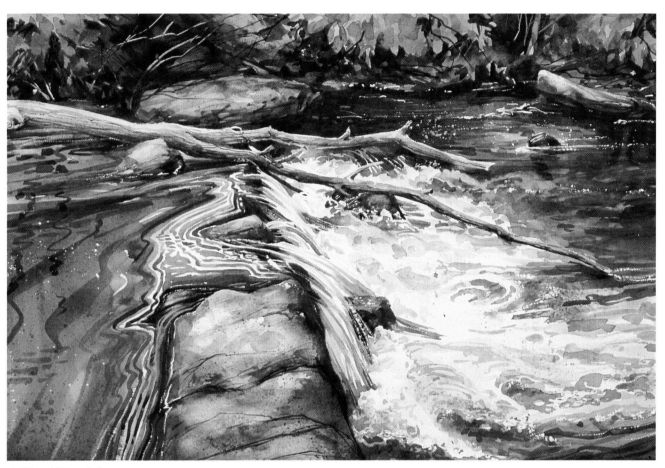

Still Pool/Waterfall
15" x 22"
Cathy Johnson
Private Collection

Reflections

Unless it is an extremely overcast day or the surface is whipped into an overall choppy pattern by the wind, water is a very reflective surface. The water's motion or the degree of wind determines a reflection's shape and direction in a secondary sense. Of course, the overall shape depends on what is being reflected on the water. Generally, reflections are opposite (like your face in a mirror), darker, and somewhat less distinct than their object. The sketch at left shows what is meant. Reflections are more distinct closer to their object; they are affected by water patterns farther out.

Cast Your Nets is a painting of a creek in mist with a carefully constructed spider web over the busy "insect highway" of the creekbed. The sun barely touches the water, with a bit of warmth resulting in angular reflections. Often, the problem with painting a scene like this is in not being bold enough. A bit of spattered frisket retained the sparkles in the distant water. A gradated wash of thalo blue and alizarin crimson was used in the water, allowing the foreground to break into a delicate, wavy pattern. The second wash included the far light-struck bank and its reflection (upper right), and the dark, shadowed woods and their reflection (upper left). A strong mixture of Hooker's green deep, ultramarine blue, and a bit of burnt umber gives a rich, dark color that plays out into dancing reflections as it moves forward in the picture plane.

When the wash dried, the droplets of frisket were removed and the reflected sun in the water was washed back with a small, clean natural sponge dampened in clear water. The excess pigment was blotted. More warmth was painted into the sun's corona with diluted alizarin crimson. The dark twig overhanging the water and its squiggly reflection came next, painted with a liner brush. When all was thoroughly dry, the spider web was scraped in place. Be careful not to get too mechanical here! Spider webs are sometimes perfect circles—the late summer web-weavers bear this out—but this one was rather more interestingly shaped. The scraped lines give the feeling of dew-beaded strands.

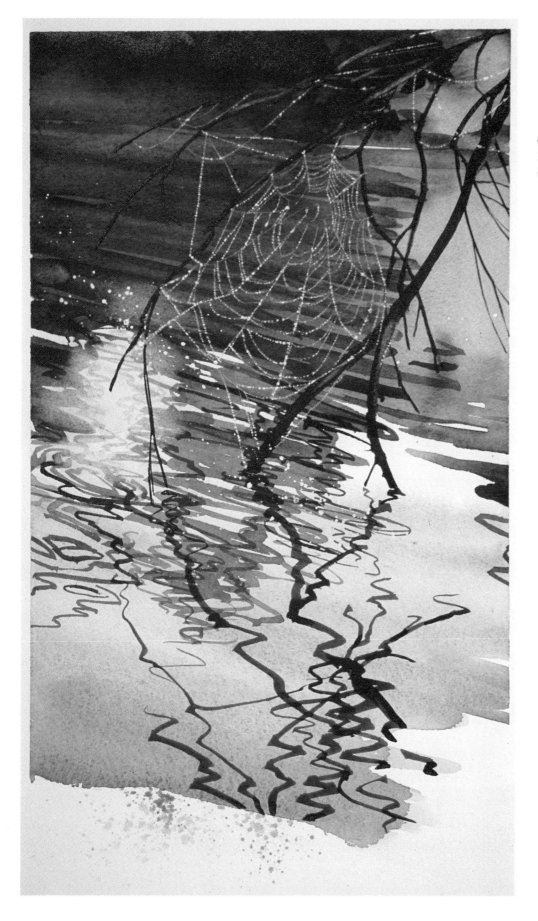

Cast Your Nets
11" x 14"
Cathy Johnson

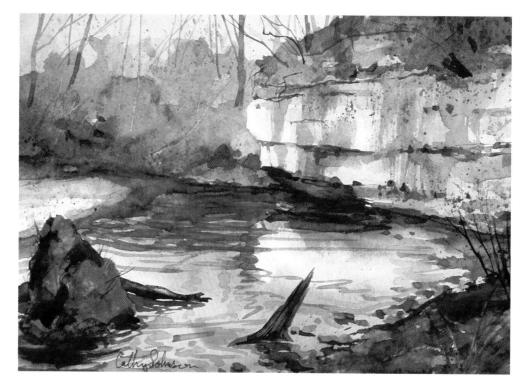

Trout Spring
9" x 12"
Cathy Johnson

In *Trout Spring*, above, the warm-colored distant bank was painted first, using cadmium orange in a mixture of burnt sienna and ultramarine blue. The limestone cliff was left white at this stage.

The water area was wet with a rich mixture of cadmium orange to reflect the warmer colors higher up on the opposite bank. Ultramarine blue, burnt sienna, and a strong dose of manganese blue helped represent the mineral-rich water of the spring where it flowed out from under the cliff. Manganese is a very sedimentary color, so it tends to stay put and not blend too much in a wet wash.

When these two areas were dry, the cliff, the sandbar on the left, and the dark foreground were painted in, using spatter and successive washes to suggest texture.

The whole area was actually in shadow; the sun hit only the tree-covered bluffs above and lit them up like a forest fire.

The foreground shapes are dark to give the feeling of depth. Dark shadows, reflections, small trees, and twigs were added last, when everything had dried thoroughly.

Don't let a tricky subject keep you from attempting at least a study. We learn, especially from our failures.

Reflections and Color

Sometimes the surface of water itself makes an interesting subject. The sky, clouds, shadowed sides of the waves, distance, light, and perspective all combine for a fascinating study. Look for unique surface patterns to present in your paintings—perhaps you'll be in the right place at the right time.

Color

Achieving the right color can be a real challenge: it defines the water patterns. Don't believe water is only blue. Its varied patterns are endlessly fascinating. Don't let anything keep you from

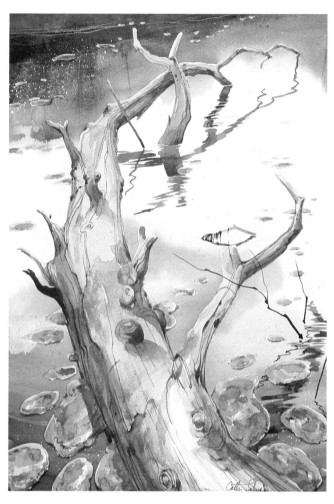

Fishin' Hole
15" x 22"
Cathy Johnson
Collection of
Mr. and Mrs. Leonard Johnson

trying a challenging subject.

A couple of small pencil sketches helped decide the format for this painting of an old, fallen tree. The broader horizontal vista was nice (top left), but almost too placid. The more dramatic vertical draws the viewer deep into the picture plane (center left). The tree and floating moss pads were protected with frisket, so the pigment could be laid in boldly after the whole board was wet with clean water. This first water was applied with a spray bottle, then spread with a wide brush to avoid getting the watercolor board too wet and having to wait until it dried to the right point. Hooker's green deep, mixed here and there with sap green and ultramarine blue was the first brave step "into the water"—gravity pulled the paint into believable reflected forms when the board was tipped up.

A rich mixture of ultramarine blue, thalo blue, and a bit of burnt umber created reflected summer sky in the foreground, then once the frisket was removed, the rest was painted fairly directly in successive washes. Reflections are most distinct close to their object, and more wavy farther away.

THE FIGURE
Adding the "Human Touch"

The figure—especially the figure in motion—can be a rather intimidating subject for a painter to approach. But adding people to your paintings adds such life and interest, you should certainly give it a try.

From Gesture to Final Figure

The gesture drawing represents the initial impression of a person destined to be used in one of your paintings. It makes a good starting point for developing the final rendering. The challenge in going from gesture to final figure is to develop the original sketch to a degree consistent with the needs of the painting without losing the sense of action, identity, or character it contains.

The transition from gesture to final figure almost never occurs in just one step. One of the preliminary steps often involves incorporating more accurate or specific information about anatomy. This is not always obvious, because the original gesture may not lend itself readily to anatomical analysis. Some of the best gesture drawings ignore the fine points of anatomy, with lines that do not correspond to the interior structure of the body. Sometimes there is a corresponding loss of convincing action when more correct anatomy is applied to gesture drawing. The best answer is a suitable compromise that retains as much as possible of the original energy, without violating the reality of correct anatomy.

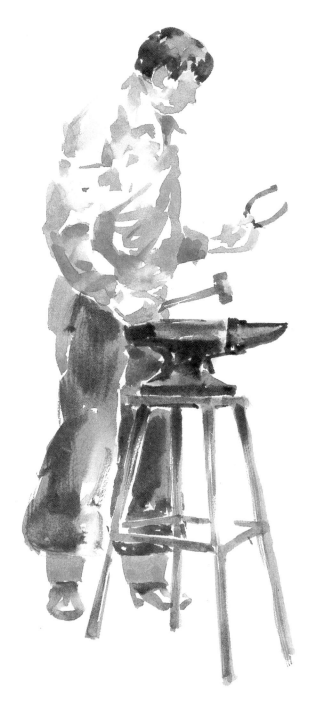

Shown here and on the next few pages are several very loose gesture drawings, resolved into final figures suitably developed for use in finished paintings. Notice that there is a loss of gestural energy and feeling of spontaneity in the final version. It is almost impossible to keep this from happening. A good gesture line has an intangible quality that can seldom be worked on without being diminished. In order for the final figure to look spontaneous, the preliminary step can be left incomplete, and the final step painted with as large a brush as is practical.

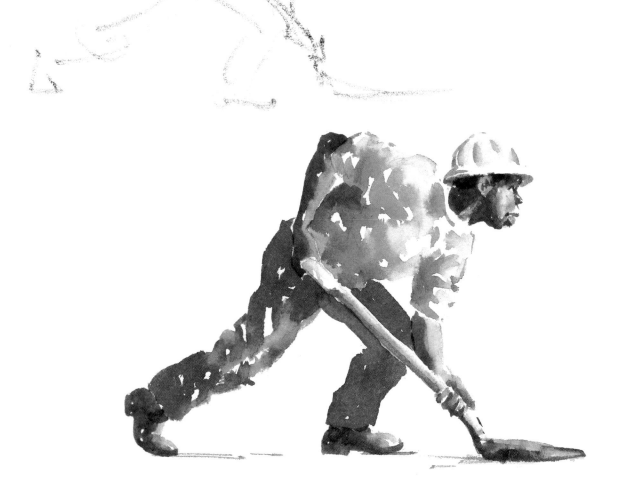

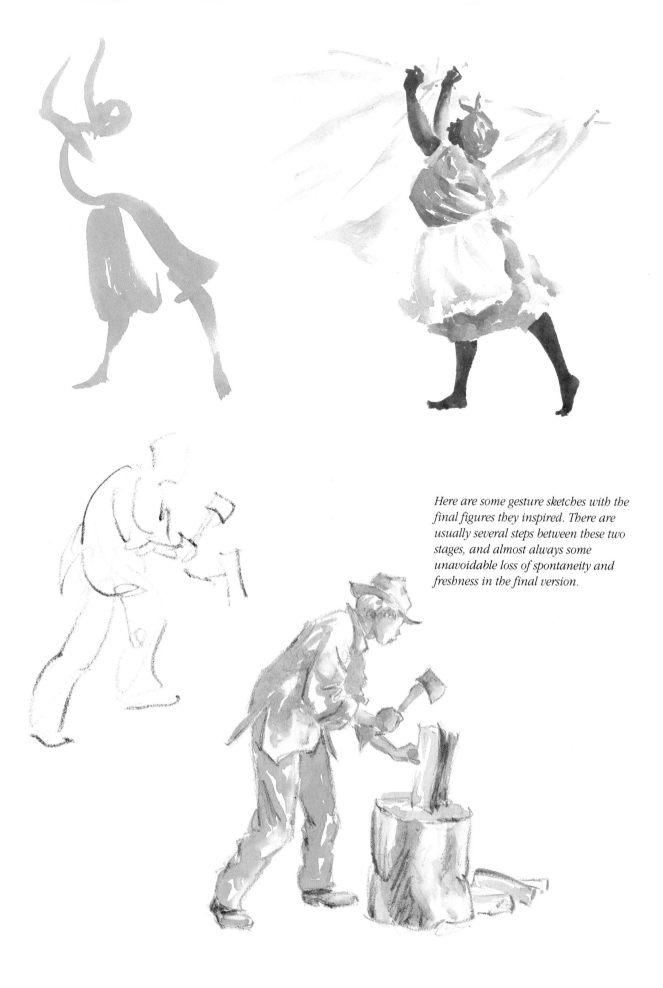

Here are some gesture sketches with the final figures they inspired. There are usually several steps between these two stages, and almost always some unavoidable loss of spontaneity and freshness in the final version.

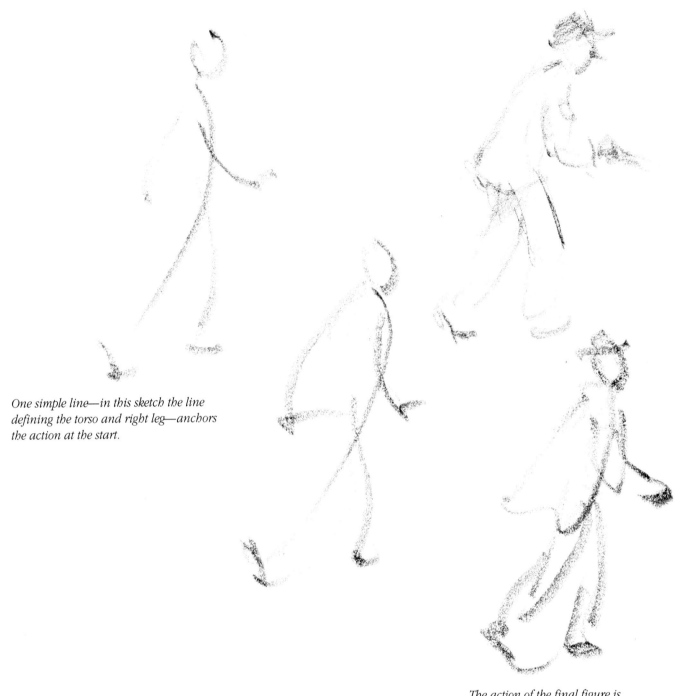

One simple line—in this sketch the line defining the torso and right leg—anchors the action at the start.

The action of the final figure is developed here, starting from the simplest pencil sketch. The action and the detail are developed simultaneously in the figure sketches that follow. Several others, not shown here, were discarded along the way. Separate sketches for each step are shown for the sake of clarity. Often in actual practice, it will be easier to erase and make changes on the starting figure sketch.

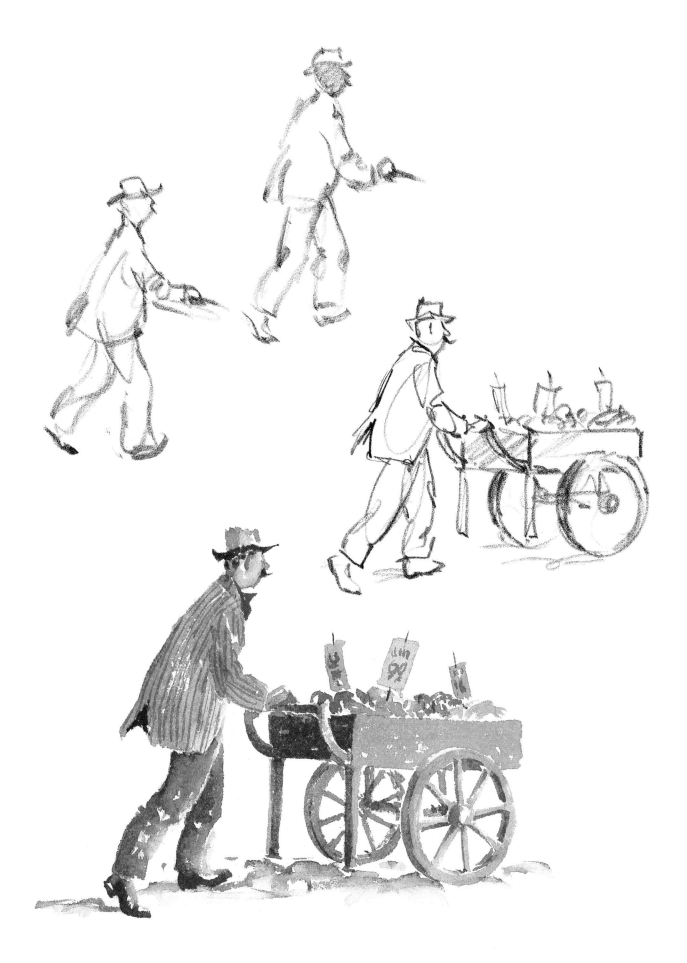

Basic Watercolor Techniques

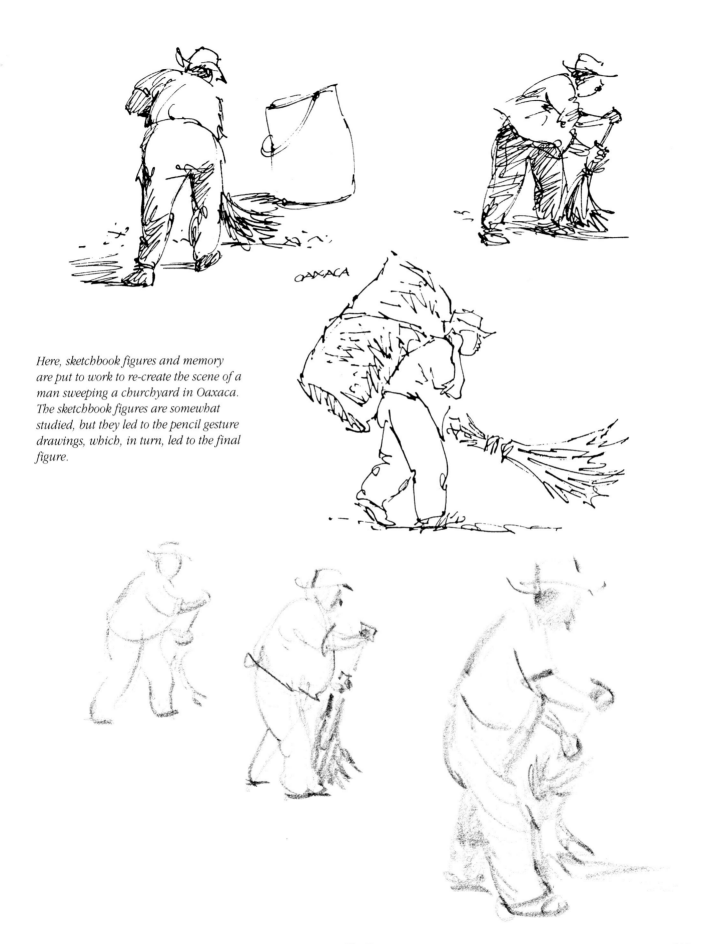

Here, sketchbook figures and memory are put to work to re-create the scene of a man sweeping a churchyard in Oaxaca. The sketchbook figures are somewhat studied, but they led to the pencil gesture drawings, which, in turn, led to the final figure.

OAXACA

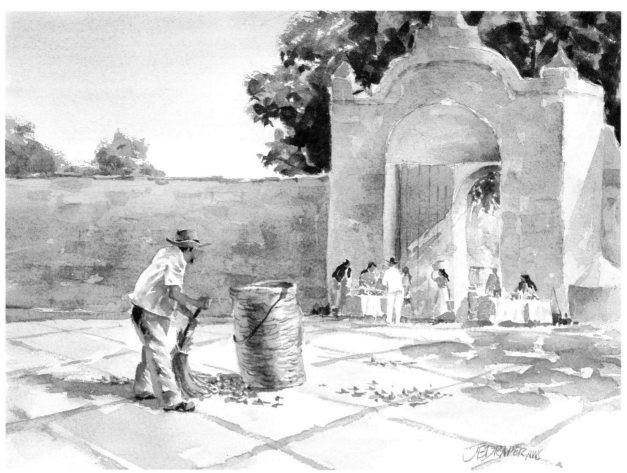

This painting was produced much later in the studio. Instead of using the yard and the gate as the subject, they become a setting for the figure of the sweeper.

Oaxaca Churchyard
20" x 15"
Everett Draper

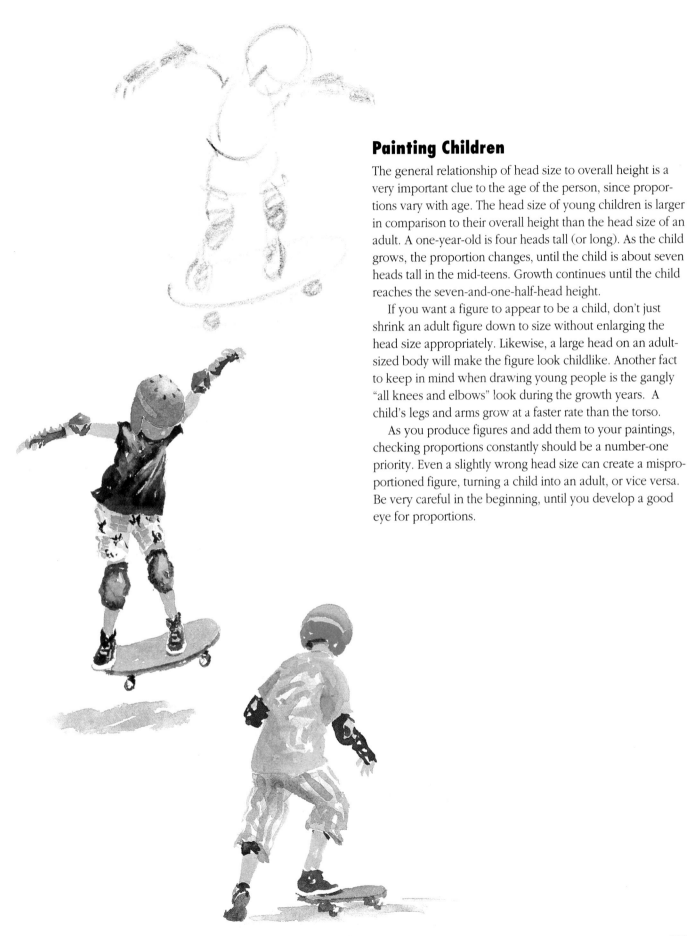

Painting Children

The general relationship of head size to overall height is a very important clue to the age of the person, since proportions vary with age. The head size of young children is larger in comparison to their overall height than the head size of an adult. A one-year-old is four heads tall (or long). As the child grows, the proportion changes, until the child is about seven heads tall in the mid-teens. Growth continues until the child reaches the seven-and-one-half-head height.

If you want a figure to appear to be a child, don't just shrink an adult figure down to size without enlarging the head size appropriately. Likewise, a large head on an adult-sized body will make the figure look childlike. Another fact to keep in mind when drawing young people is the gangly "all knees and elbows" look during the growth years. A child's legs and arms grow at a faster rate than the torso.

As you produce figures and add them to your paintings, checking proportions constantly should be a number-one priority. Even a slightly wrong head size can create a misproportioned figure, turning a child into an adult, or vice versa. Be very careful in the beginning, until you develop a good eye for proportions.

THE PORTRAIT
Meeting Your Subject Head-On

Portraying a Young Boy

Many painters would like to do portraits of their own or other people's children, but are afraid to attempt this difficult subject. The following demonstration shows how to approach a watercolor portrait—from drawing to finished painting. This painting was done from a photograph; usually the best way to work with impatient children. Notice that the artist did not attempt to duplicate the photo, but actually improved upon it.

This demonstration evolved from a snapshot of a handsome young man named Greg. The photo was taken in the shade with only a suggestion of shadows on his face. It's far easier to get a likeness if you can see the shadows clearly. Failing that, the next best thing is to carefully draw the head and locate shadow areas, as in the sketch.

Here are a few suggestions if your model does not have strong shadows. Study the face carefully; it may be possible to locate a hint of shadow. If you're not using a model, or if you can see no trace of shadow, find a photograph where the shadows fall in the desired manner. If all else fails, study your own face in a mirror. Stand in the light so the shadow falls on your face in much the same way as you want the shadow to appear on your model.

Now back to the model. Draw the facial outline on your sketch paper, and block in the shadows (do this on a tracing paper overlay) as they appear on your surrogate model. It's easier than you may think to create a convincing shadow side.

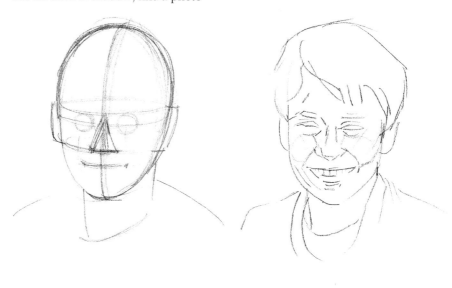

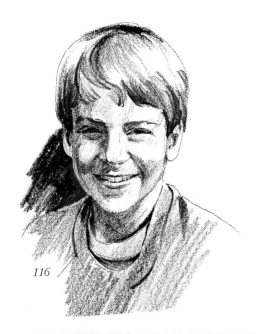

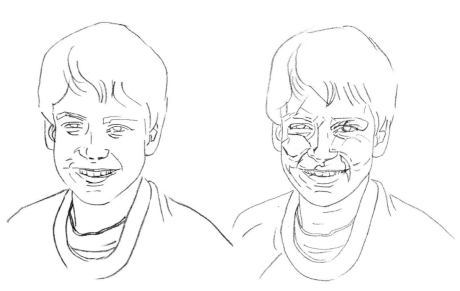

Step 1. The painting process begins with a wash of new gamboge, combined with Winsor red and applied with a no. 10 round brush and enough water to keep the surface somewhat fluid. A dilute mixture of new gamboge and sap green was quickly added into the area of the hair, so the color could blend at the forehead. There was a small white (unpainted) highlight in his cheek. This was left in at this stage, and the decision whether or not to keep it determined later.

Step 2. For the shadow side, keep the area around the eyes cool, and blend the color into a near red around the nose and mouth. To do this, a grayed green was mixed on the palette, using sap green and cadmium red. This is a safe combination in light values. (Remember, complementary mixtures in values darker than 6 equal *mud*.) The skin color is at value 1; therefore, this gray-green need only be at value 5.

Next, puddles of alizarin crimson and burnt sienna and of alizarin crimson and Winsor blue were mixed. After all the colors were tested for value, three trusty no. 6 brushes were loaded, each with one of these mixes.

With the sketch for a guide, the brush was dipped into the purple mix and, beginning at the hairline, the color was drawn down into the right eye. Quickly switching to the green brush, color was continued to his nose. The red brush completed the shadow shape. Before this dried, new gamboge was dropped along the jawline and at the tip of the nose to suggest reflected light. The left eye got a splash of green. By rinsing the brush with clear water, it can be dipped into the still-wet pigment (on the paper) and a lighter value of this green can be pulled across the brow to suggest the indentation that is almost always present between the eyes.

Since the shadows are indistinct in the photo, (top left), *it took extra time to locate them on the sketch and preliminary drawings.*

Step 3. Now it's time to begin modeling in earnest. Beginning with the sunlit side, color was added to the cheek. The areas that are somewhat turned away from direct light receive a cooler blue-red. The colors are alizarin crimson, burnt sienna, and cadmium red.

Various combinations of alizarin crimson, Winsor blue, and burnt sienna were used to model the shadow side.

The shirt will be painted blue, so blue is added to the neck to suggest sunlight bouncing off the inside of the collar.

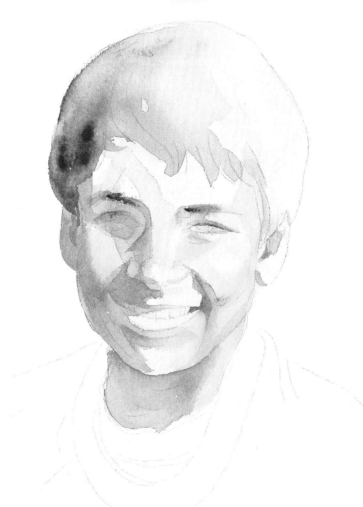

Step 4. There is a lot of color in Greg's dark hair. This is an opportunity to be bold and add brilliance to the painting. Following the contour of his head, pure color was added, laying one brushstroke at a time next to another and permitting the color to combine freely on the paper. This is when watercolor is really exciting—it almost paints itself!

Since the colors on the snapshot are pale, it's easy to make the mistake of painting the shadow side in too light a value. This requires checking the value scale frequently to make sure the shadows are dark enough.

Basic Watercolor Techniques

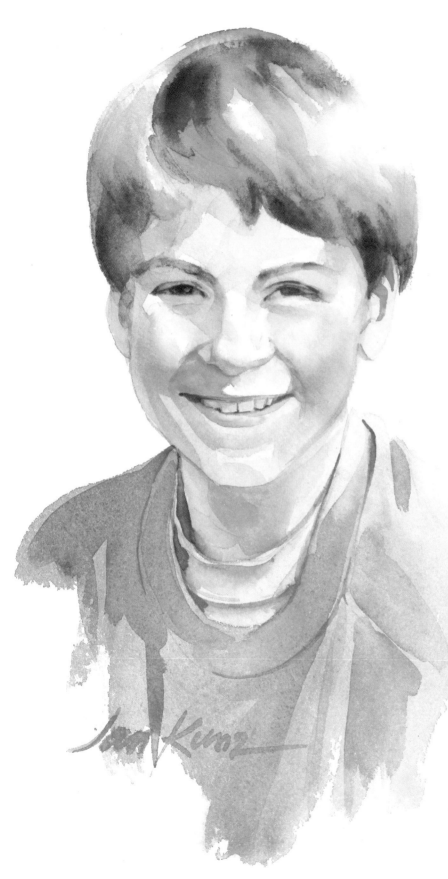

Step 5. In this last phase, as in the previous one, the final darks are added at the corners of the mouth and in the shadows of his neck. The colors for all such darks are usually a combination of alizarin crimson and burnt umber.

After painting the clothing, some background color was introduced to help distinguish the edge of Greg's cheek. Finally, using a small, stiff, oil-painter's brush that had been slightly moistened, edges that might require a little help were softened. That little white highlight on his cheek is still there, but it's almost unnoticeable.

The twinkle in his eye and that big grin tell you he is warm and caring—and full of mischief! Anyway, with or without shadows, Greg is a great model.

INDEX